Imprint

Bibliographic information

published by the Deutsche Nationalbibliothek
The Deutsche Nationalbibliothek lists this publication
in the Deutsche Nationalbibliografie; detailed bibliographic data
is available on the Internet at http://dnb.d-nb.de

Translation: Wendy Wallis, Berlin

Layout: h neun Berlin

Printed and bound by Medialis Offsetdruck GmbH, Berlin

First English Edition 2009

www.deutscherkunstverlag.de

ISBN 978-3-422-06893-3

Cover illustration: Alte Nationalgalerie, Perron

Museum Island Berlin

and Its Treasures

Published by
the Staatliche Museen zu Berlin
and bpk – Bildagentur für Kunst, Kultur und Geschichte

Image Selection and Texts
Hans Georg Hiller von Gaertringen

Deutscher Kunstverlag

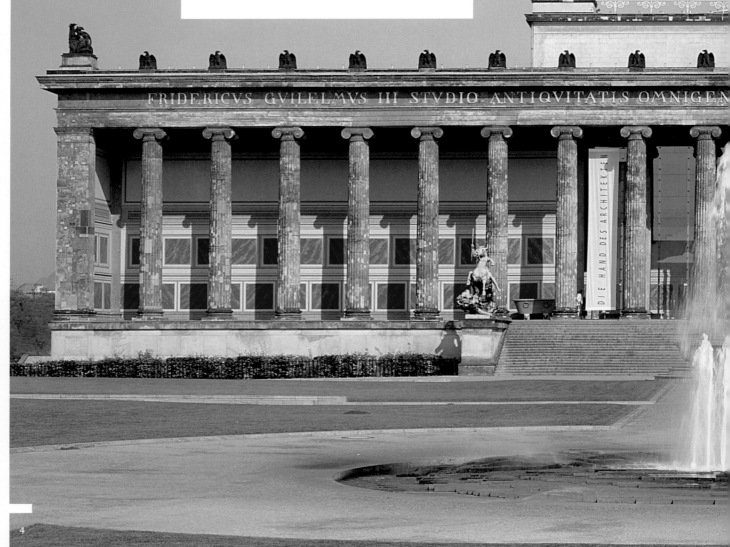

Altes Museum

The «Old Museum» is one of the oldest independent museum buildings in Germany. It was built in 1825–30 from designs by the Neoclassical architect Karl Friedrich Schinkel. Originally, the columned front to the pleasure garden faced the Berlin City Palace (plans to rebuild the palace should be implemented in the next few years). The museum houses the art of classical antiquity, especially sculptures, amphorae and mosaics.

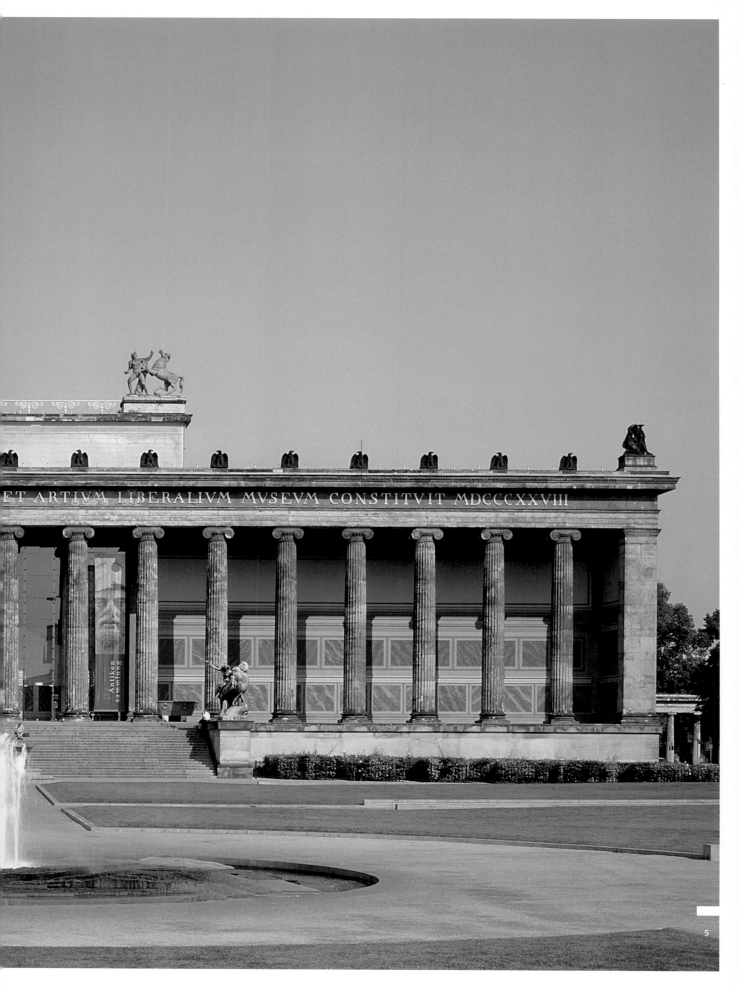

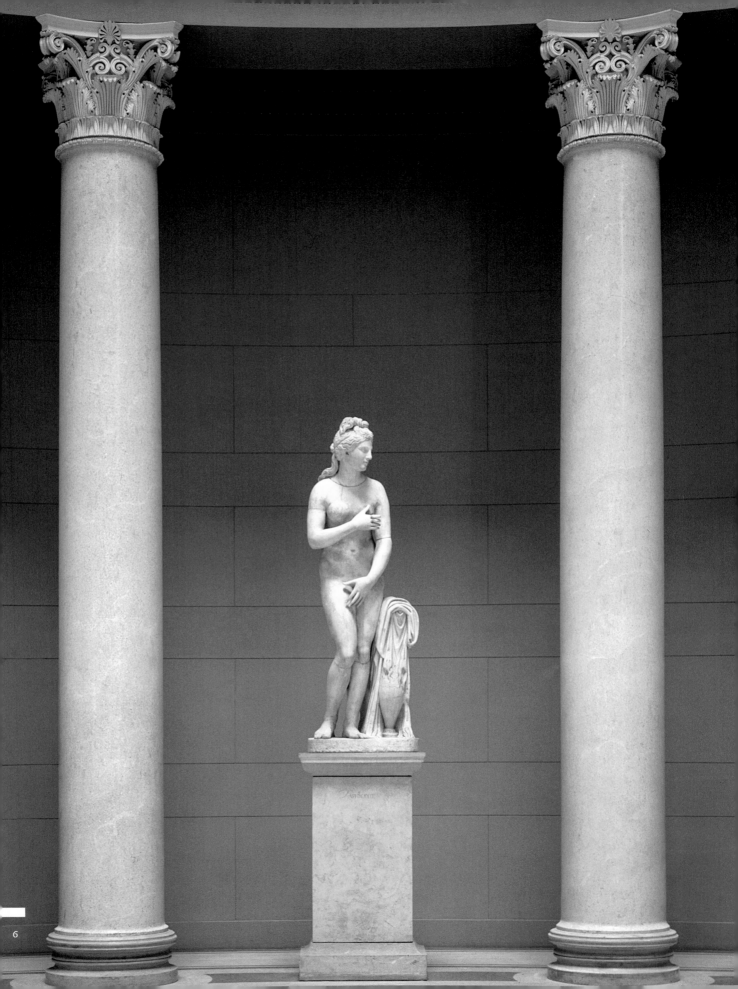

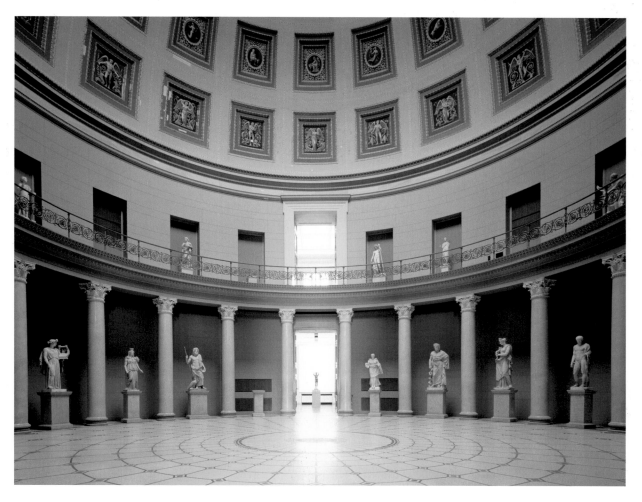

Rotunda

The rotunda is the central interior of Schinkel's museum. He envisioned that the most precious objects in the collection would be displayed here. Statues of the most well-known Greek and Roman gods were positioned between the columns even then.

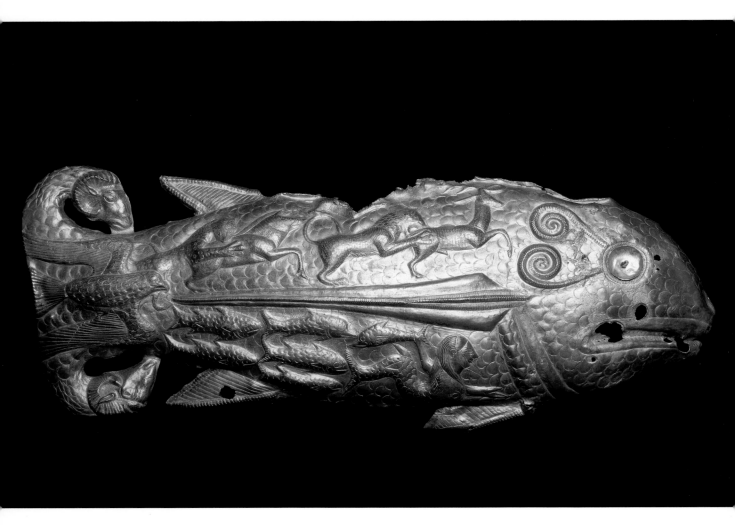

Fish from Vettersfelde

Scythian, c. 500 B.C.

In 1882, a farmer in Lower
Lusatia discovered several
pieces of finely worked jewelry
and ornamental weapons
made of gold. They are works
by Scythians, a nomadic eques-
trian people, who in fact lived
in the region of modern Ukraine.
This fish, decorated with
several animals and a bearded
sea creature, is the most im-
pressive work from this fascinat-
ing discovery. It was presum-
ably once attached to a shield as
ornamentation.

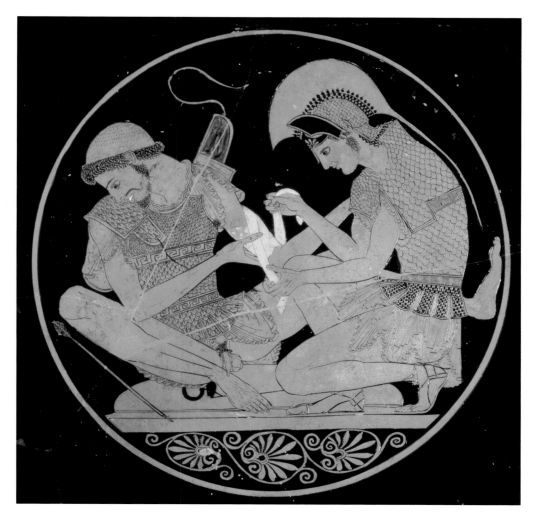

Sosias Painter

**Drinking cup with a depiction
of Patroclus and Achilles**
Vulci (Italy), c. 500 B.C.

The drinking cup shows a scene
from the Trojan War. Patroclus
has just been wounded by
an arrow and is being bandaged
by his best friend, the young
Achilles. In great pain, Patroclus
has turned his head away so
as not to watch. The scene is exe-
cuted in the red-figure style,
in which the figures are omitted
from the black cover layer of
paint and consequently appear
bright orange after firing.

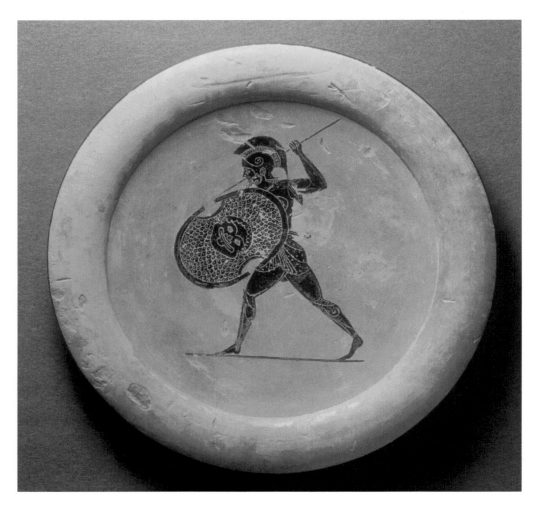

Psiax (?)

**Plate depicting a warrior
with a lance**
Greece, c. 520 B.C.

A warrior in full armor, who
is about to attack an opponent,
is painted in black at the
center of the plate. It is be-
lieved that such artistically
painted objects were not meant
for daily use. Instead, they
were presumably created for
ceremonial events.

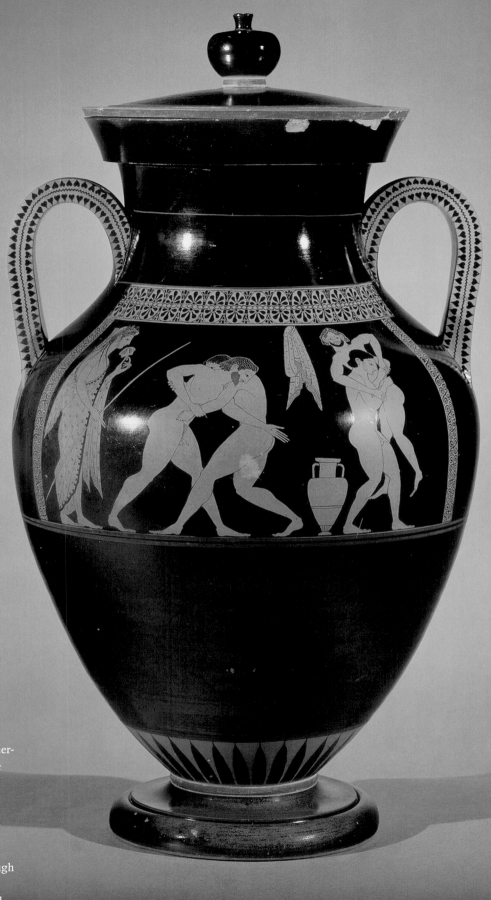

ANDOKIDES

**Amphora with a depiction
of a wrestling school**
Vulci (Italy), c. 530–525 B.C.

Vase painters and potters in
the ancient world did not gener-
ally sign their works. Despite
the masterly extent of their
artistic abilities, their names
are mostly unknown. In this
case, the noted name of the
potter – Andokides – was at-
tributed to the painter although
they are not the same artist,
but merely often collaborated

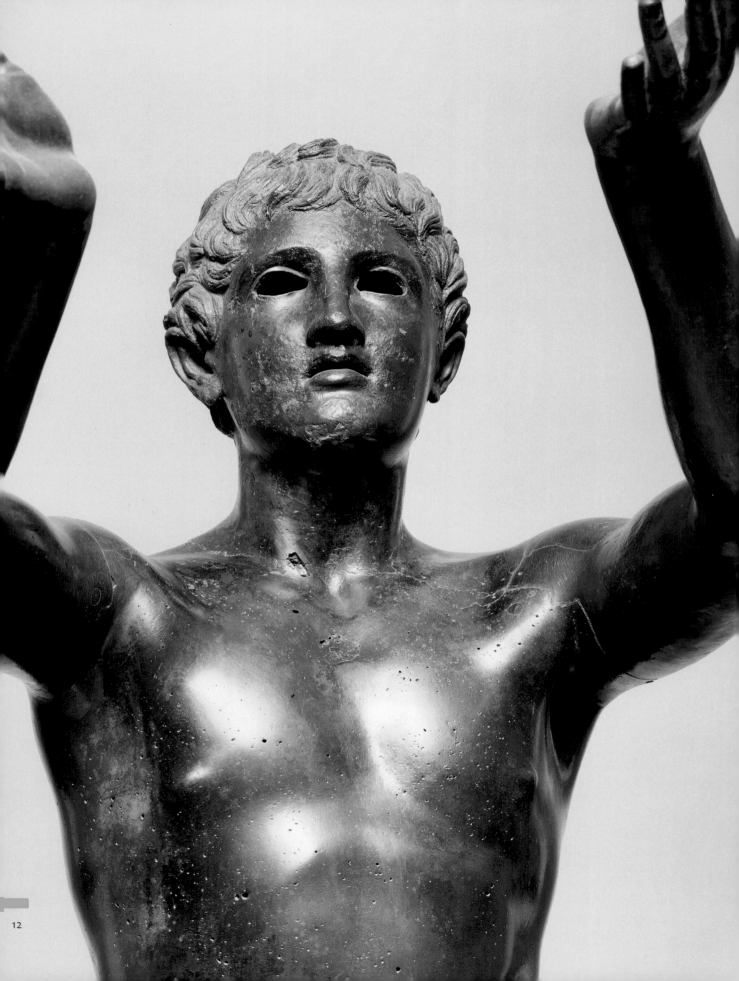

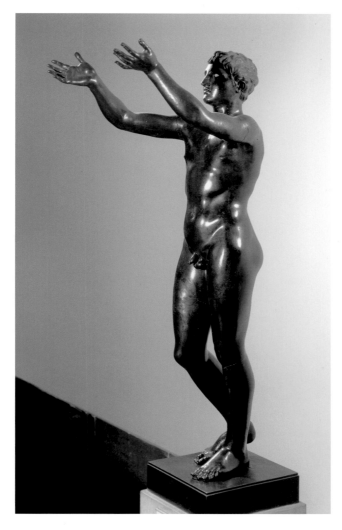

SCHOOL OF LYSIPPOS

The Praying Boy
Rhodes, c. 300 B.C.

Original bronze figures from
the Greek Age are rare and there-
fore particularly valued. Both
arms of the bronze figure were
missing when the so-called
«Praying Boy» was discovered on
Rhodes in 1503. Its damaged
condition was not considered
acceptable and consequently the
original poses of the arms
were arbitrarily reconstructed.
Following an odyssey through
various collections, the figure
came into the possession
of Frederick the Great in 1747.

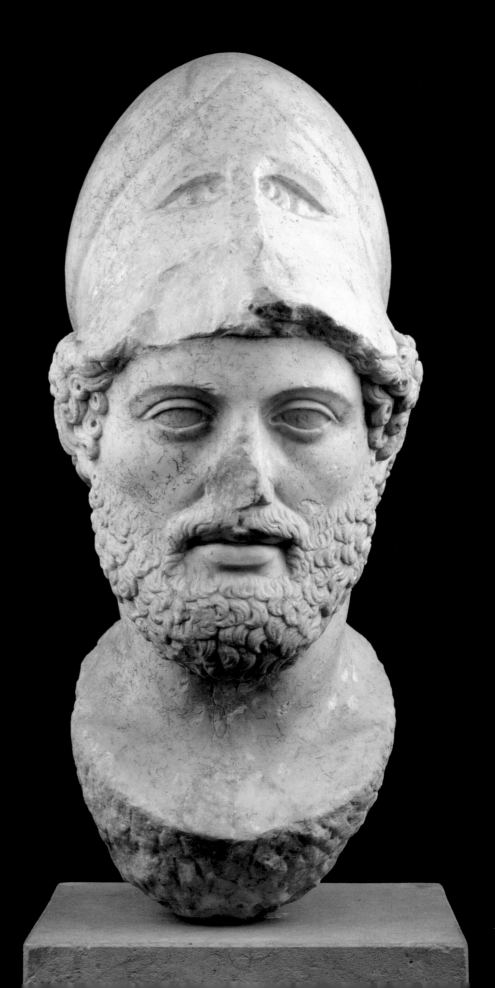

Pericles

*Roman copy of a Greek original,
c. 430 B.C.*

The Greek politician and military leader led Athens into the Peloponnesian War against Sparta in 431 B.C. Accordingly, he is shown here as a soldier with his helmet pushed up on his head. However, the war proceeded unfavorably causing Pericles to be discharged and even indicted in 430 B.C. He would not be glorified as a democratic reformer and a supporter of philosophers until centuries after his death, primarily through his Roman biographer Plutarch.

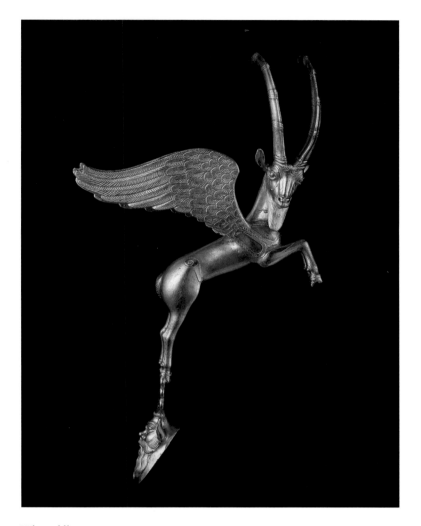

Winged ibex

Persia, 1st half of the 4th century B.C.

The Greeks and Romans were not alone in creating outstanding works of art during antiquity. This salient ibex illustrates that the highest artistic standards were also achieved in the arts and crafts of ancient Persia. The gracefully built silver animal originally served as the handle of a vessel. It was certainly not meant for use in daily life, but was a luxury object through which the wealth and taste of its owner could be demonstrated.

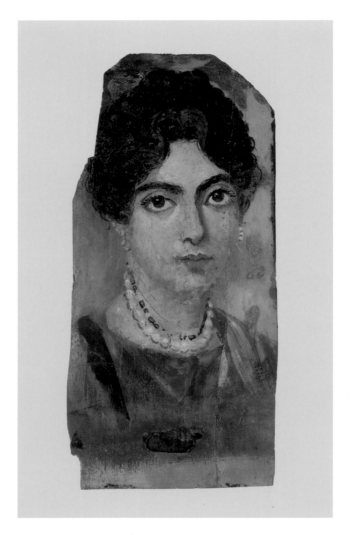

**Fayum mummy portrait
of a young woman**
Roman, c. 140 A.D.

Painting in antiquity is rare. Although it is known through writings that many important painters were active in the ancient world, nearly all of their works have been lost over the course of centuries. Nonetheless, painted portraits of the dead have been preserved in graves in the dry climate of Egypt. The woman portrayed, elegantly dressed in a pearl necklace and purple cloak, is one of the rare examples showing the skills of portrait painters during the Roman period.

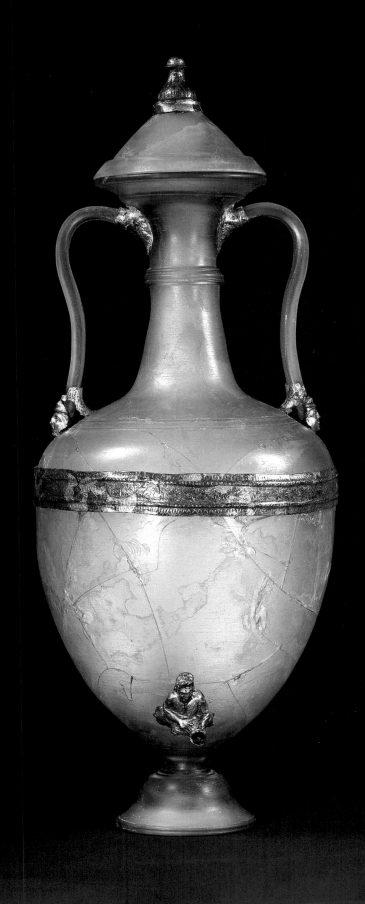

Glass amphora

Olbia on the Black Sea, c. 100 B.C.

Works of art made in glass had already achieved an exceptional level of craftsmanship during the Greek Age. Few of these fragile objects have been preserved to this day. This amphora is the largest surviving glass vessel in the world and is therefore one of the quite exceptional treasures on Museum Island. The glass that is now clouded was once transparent. The precious object was found in a region of modern Ukraine, attesting to the enormous dissemination of the Greek culture.

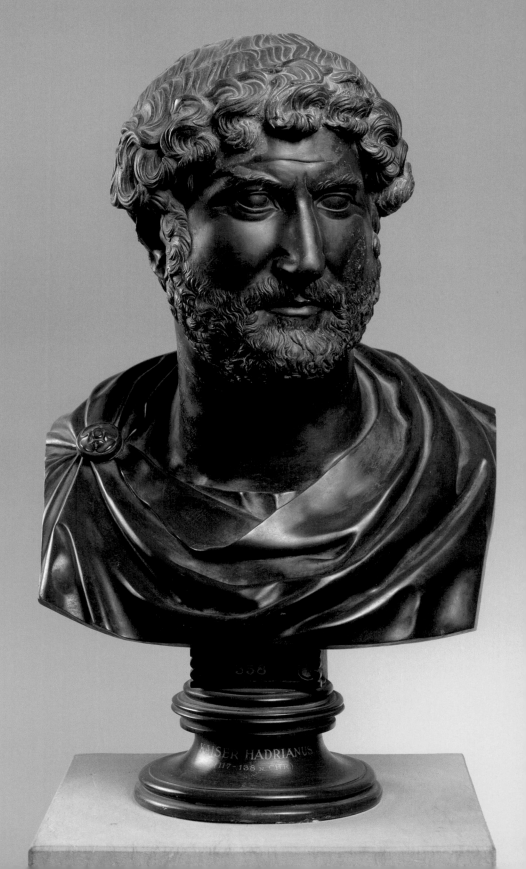

Bust of the Roman Emperor Hadrian

120—130 A.D.

The Roman Empire flourished under Hadrian's reign. He successfully stabilized the extensive empire and reformed its administration. He was a clever and educated man and has come down in history as a «philosopher emperor.» This bust made of dark green basalt demonstrates Hadrian's special admiration for Greek culture, because he was the first Roman emperor to have himself portrayed with a beard like the Greek philosophers.

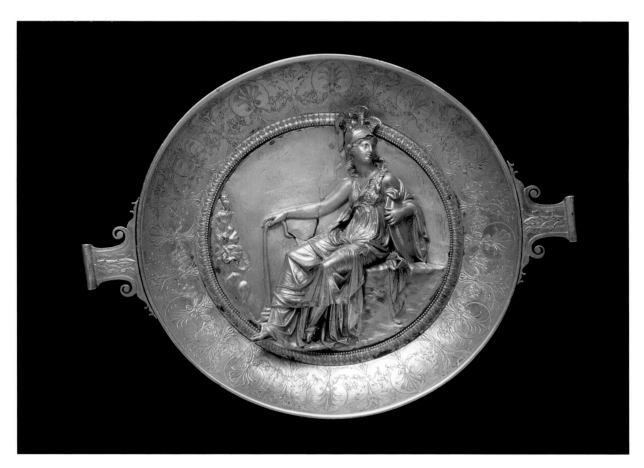

**Silver bowl with a depiction
of the goddess Minerva**
late 1st century B.C.

In 1868 an elaborate silver treas-
ure from antiquity was found in
Hildesheim (Lower Saxony),
far removed from the outer limits
of the former Roman Empire.
It was perhaps the buried spoils
of a raid by Germanic tribes.
The partially gilded silver bowl
showing Minerva, the ancient
goddess of wisdom, was created
during the reign of Emperor
Augustus. Her heraldic animal,
the owl, sits on a rock beside the
goddess.

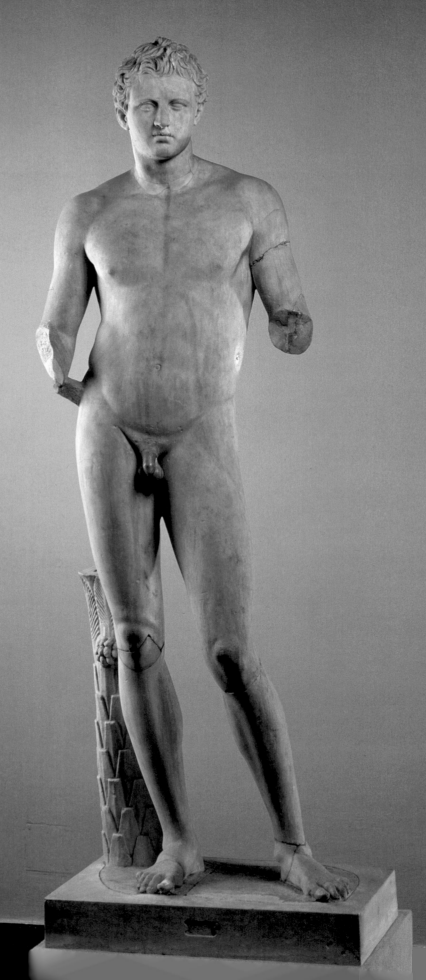

CIRCLE OF LYSIPPOS

«Berlin Athlete»
*Roman copy of a Greek bronze statue,
c. 315 B.C.*

The so-called «Berlin Athlete»
presumably held an oil vial in one
hand. This marble copy from the
Roman period can possibly
be traced back to a Greek bronze
statue made by the sculptor
Lysippos. His figures are char-
acterized by slim bodies of slight
build. The «Athlete» arrived in
Potsdam in the 18th century and
was initially placed in front of
Frederick the Great's New Palace.

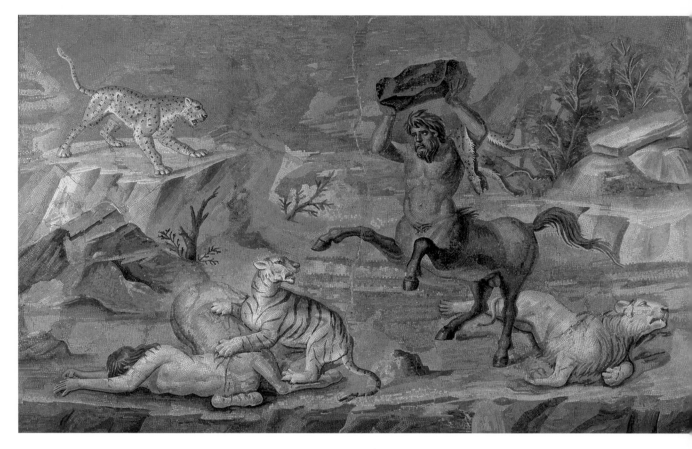

Centaurs

*mosaic from Hadrian's Villa
in Tivoli (Italy), 120–130 A.D.*

Not far from Rome, the Emperor
Hadrian owned a splendid
country estate, one of the largest
palace complexes in the ancient
world. The mosaic, showing
a fight scene, was installed on the
floor of a prestigious room.
Two centaurs – creatures that are
half human and half horse ac-
cording to classical mythology –
have been surprised by beasts
of prey. The female centaur and
a lion are already dead, as the
male centaur attempts to avenge
his companion with a rock.

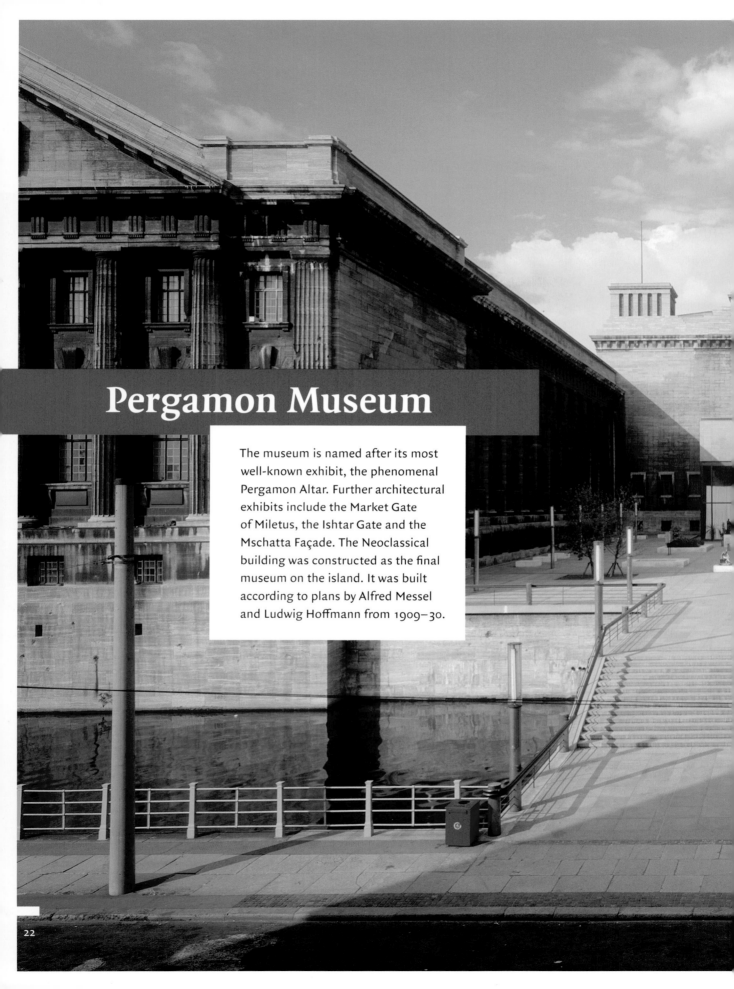

Pergamon Museum

The museum is named after its most well-known exhibit, the phenomenal Pergamon Altar. Further architectural exhibits include the Market Gate of Miletus, the Ishtar Gate and the Mschatta Façade. The Neoclassical building was constructed as the final museum on the island. It was built according to plans by Alfred Messel and Ludwig Hoffmann from 1909–30.

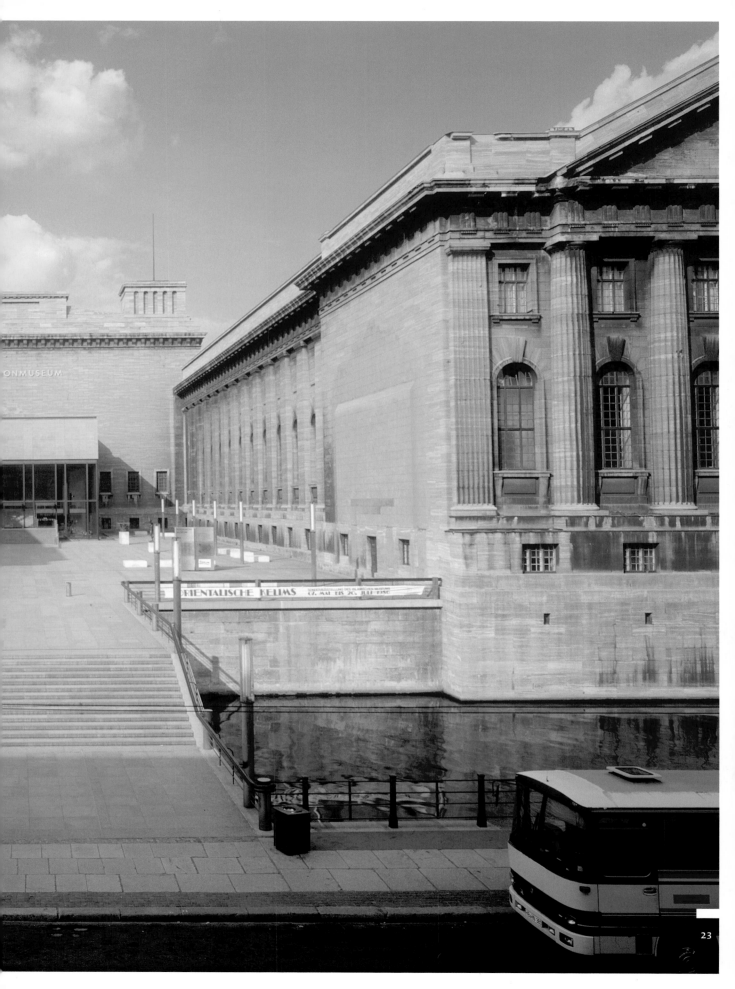

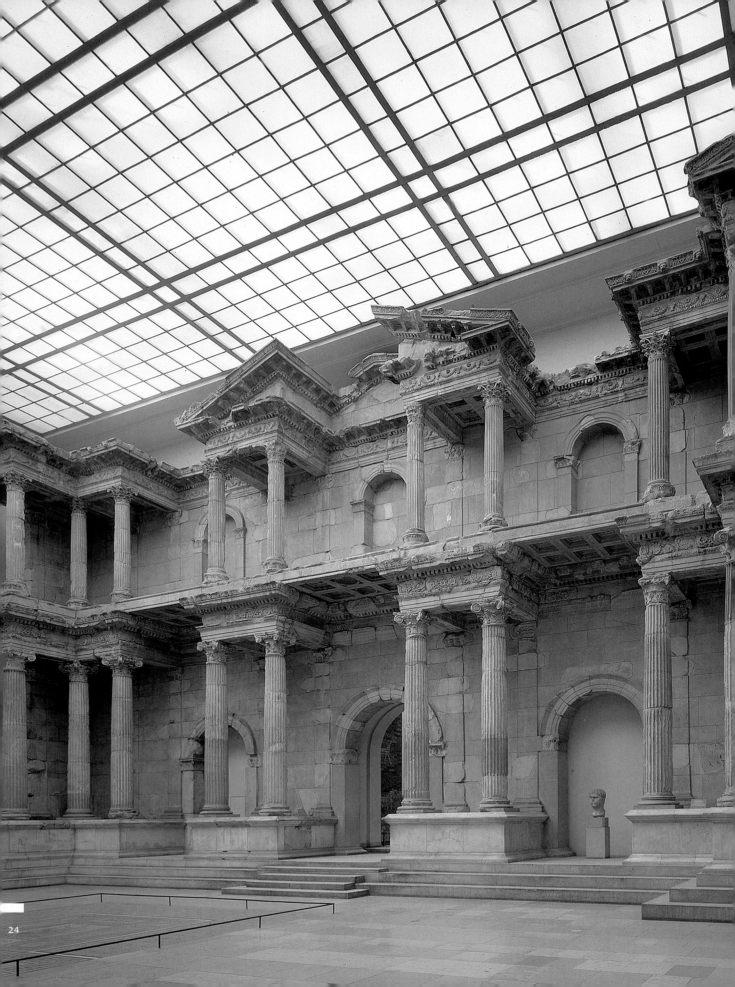

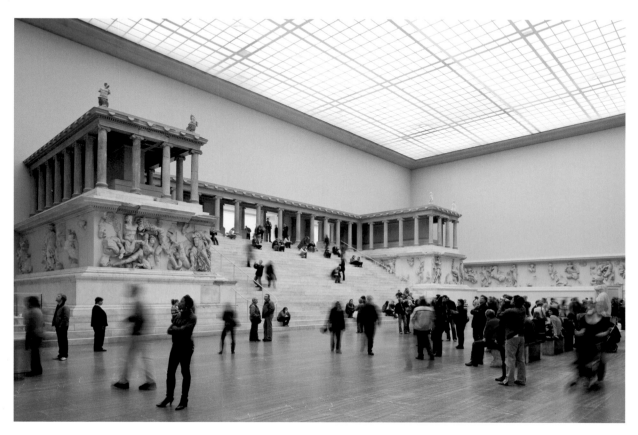

Market Gate of Miletus (left)
Miletus (Asia Minor), 120–130 A.D.

The two-story Market Gate of Miletus
on the Aegean Coast of Turkey dates
from the period of the Roman Emperor
Hadrian. It was destroyed by an earth-
quake during the Middle Ages and
was first reassembled at the museum.

Great Altar of Pergamon (top)
Pergamon (Asia Minor), c. 175–150 B.C.

The Pergamon Altar was an important
cult site of the ancient city of Perga-
mon, located in what is now modern
Turkey. The frieze depicting the Battle
of the Giants that encircles it is
regarded as a major work of Hellenistic
sculpture.

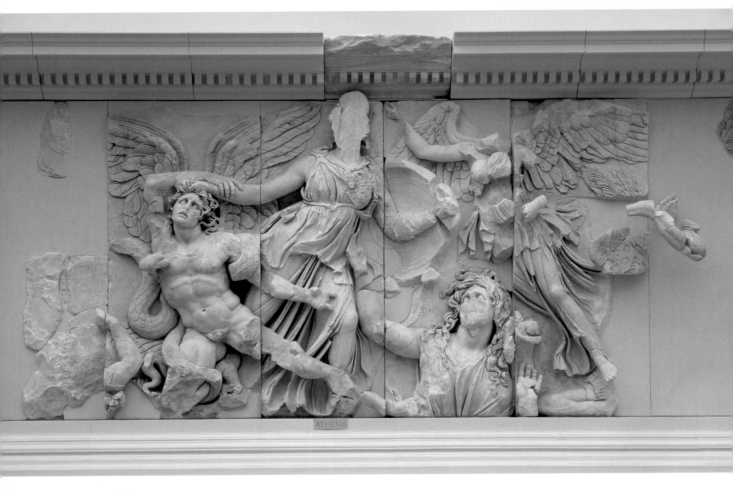

Pergamon Frieze:
Athena in Battle with the Giant
Alcyoneus and Gaia
c. 175–150 B.C.

The theme of the frieze is the
victorious fight of the Olympian
gods against the giants. This
scene illustrates the muscular
giant Alcyoneus dying from
the bite of a snake sent by the
goddess Athena. She is
shown standing above him.
In Greek mythology the battle
against the giants is often
used to symbolize the victory of
order over chaos.

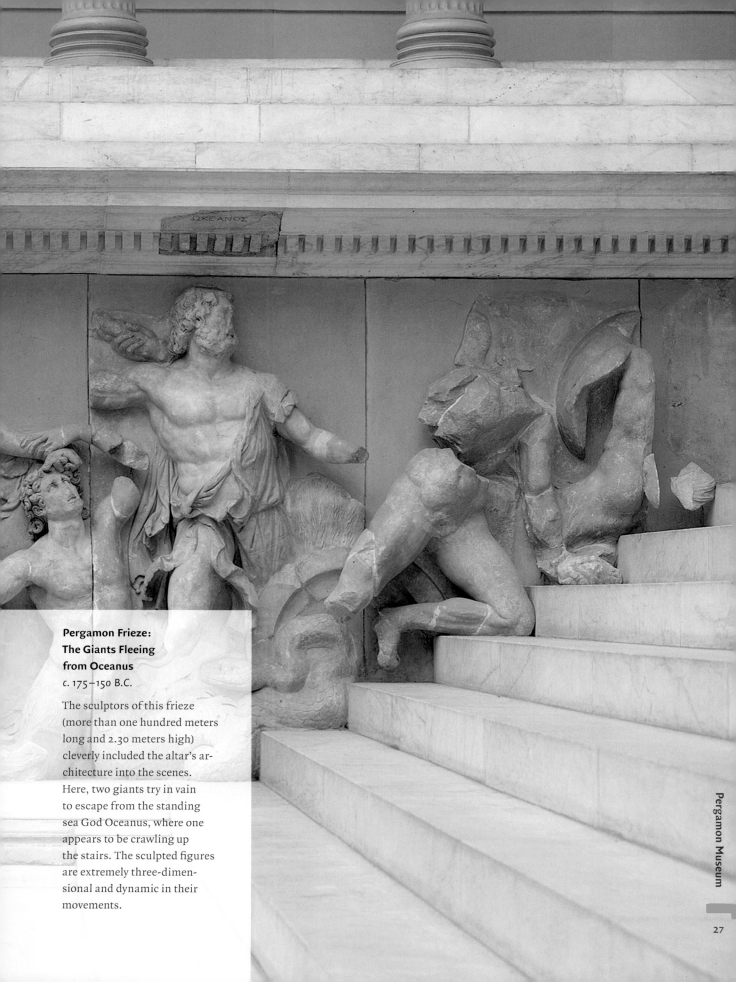

ΩΚΕΑΝΟΣ

**Pergamon Frieze:
The Giants Fleeing
from Oceanus**
c. 175–150 B.C.

The sculptors of this frieze
(more than one hundred meters
long and 2.30 meters high)
cleverly included the altar's ar-
chitecture into the scenes.
Here, two giants try in vain
to escape from the standing
sea God Oceanus, where one
appears to be crawling up
the stairs. The sculpted figures
are extremely three-dimen-
sional and dynamic in their
movements.

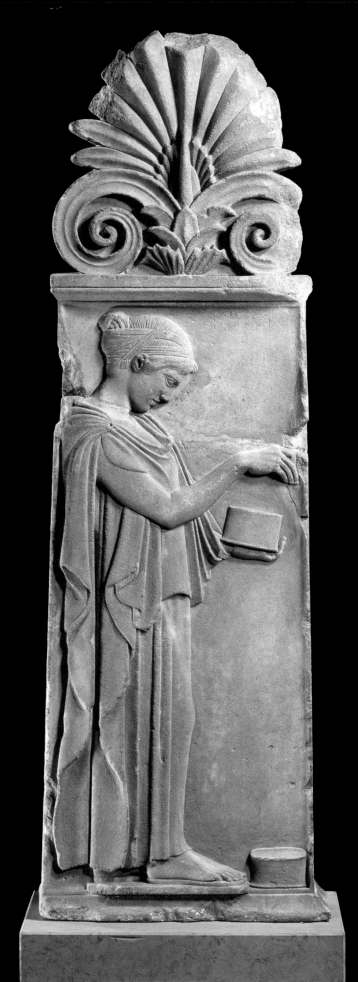

Grave stele of a girl

The island of Paros, c. 460 B.C.

The relief, crowned by a pal-
mette, commemorates a girl
who died young. Shown serious
and contemplative, she looks
at a small box from which
she seems to take something.
Whether this action was related
to her bridal jewelry or an
offering of incense can no longer
be determined, since this paint-
ed detail has vanished over
time. Grave stelae belonged
to the most important commis-
sions for Greek sculptors and
this relief is regarded as one of
the more beautiful examples.

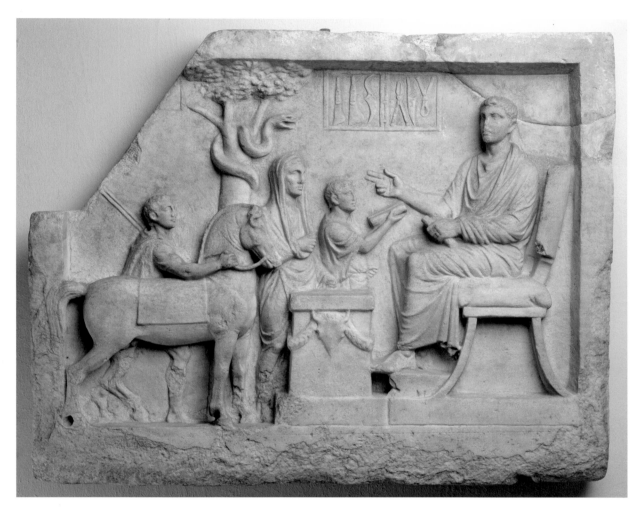

Relief depicting a doctor
c. 50 B.C.–50 A.D.

Because of their capabilities, doctors were held in especially high esteem in the ancient world. In all probability this relief was originally set up at the grave of the doctor seated on the right. His profession is recognizable through the surgical instruments hanging in the background. It also shows two young men, one with a horse, and a woman approaching from the left. They wish to show reverence to the dead man by leaving sacrificial offerings for him on the altar at the center.

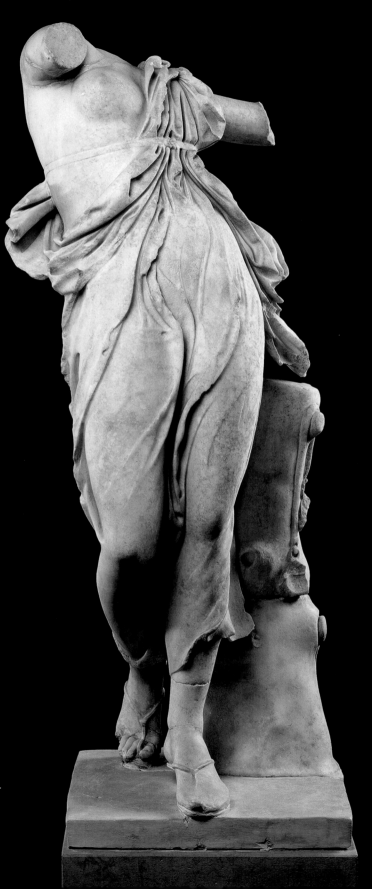

«Berlin Dancer»

Rome c. 150–200 A.D.
(copy of a Greek bronze statue,
c. 150–100 B.C.)

The feet of the dancing girl
barely touch the ground.
Her thin garment, a chiton,
is pressed close to her body
through her movements.
The figure may have held
a flute or a sacrificial animal
in her missing hands.
A cymbal hanging on the
tree trunk supports an inter-
pretation of the figure
as a Maenad, a companion
of the god Dionysus.

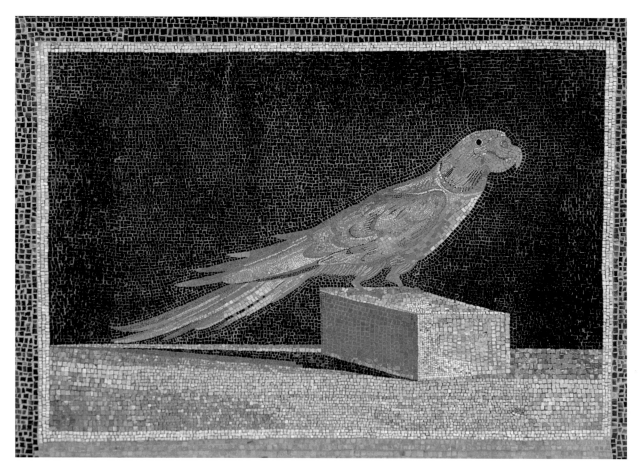

Floor mosaic

Pergamon (Asia Minor),
mid-2nd century B.C.

The bird, which can be
identified as an Alexandrine
Parakeet, is from a room
of the royal palace in Pergamon
where presumably one of
the Greek gods (Dionysus
Kathegemon) was venerated.
The image (only preserved
as a modern copy today)
was assembled from countless
tiny stones, placed closely
together, making it look as if
it were painted. Pergamon
was a center of Hellenistic
mosaic art.

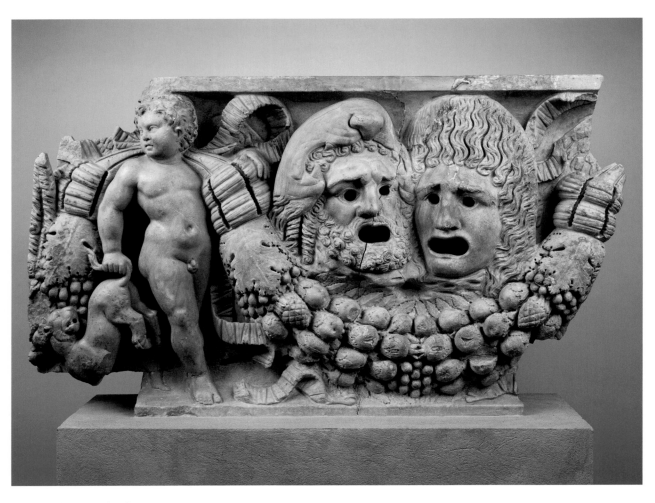

Eros carrying a garland

*fragment of a sarcophagus,
Rome, 120–130 A.D.*

The chubby-faced, muscular Eros
seems to have hardly any trouble
at all carrying the heavy garland
strung with three rows of fruit.
He even has one hand free with
which to grab a panther by the tail.
Masks are also represented,
resembling those worn by actors.
Prosperous Romans were buried
in such sarcophagi. The rich
decoration can be explained by the
fact that they were not buried
in the ground, but mounted to the
walls of tomb buildings.

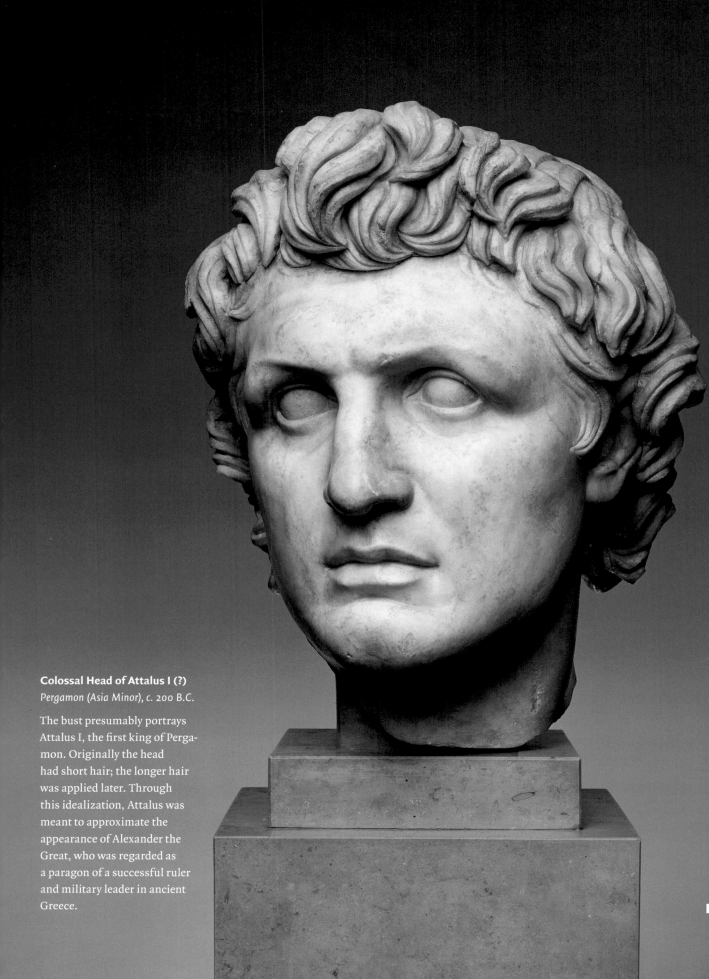

Colossal Head of Attalus I (?)
Pergamon (Asia Minor), c. 200 B.C.

The bust presumably portrays
Attalus I, the first king of Perga-
mon. Originally the head
had short hair; the longer hair
was applied later. Through
this idealization, Attalus was
meant to approximate the
appearance of Alexander the
Great, who was regarded as
a paragon of a successful ruler
and military leader in ancient
Greece.

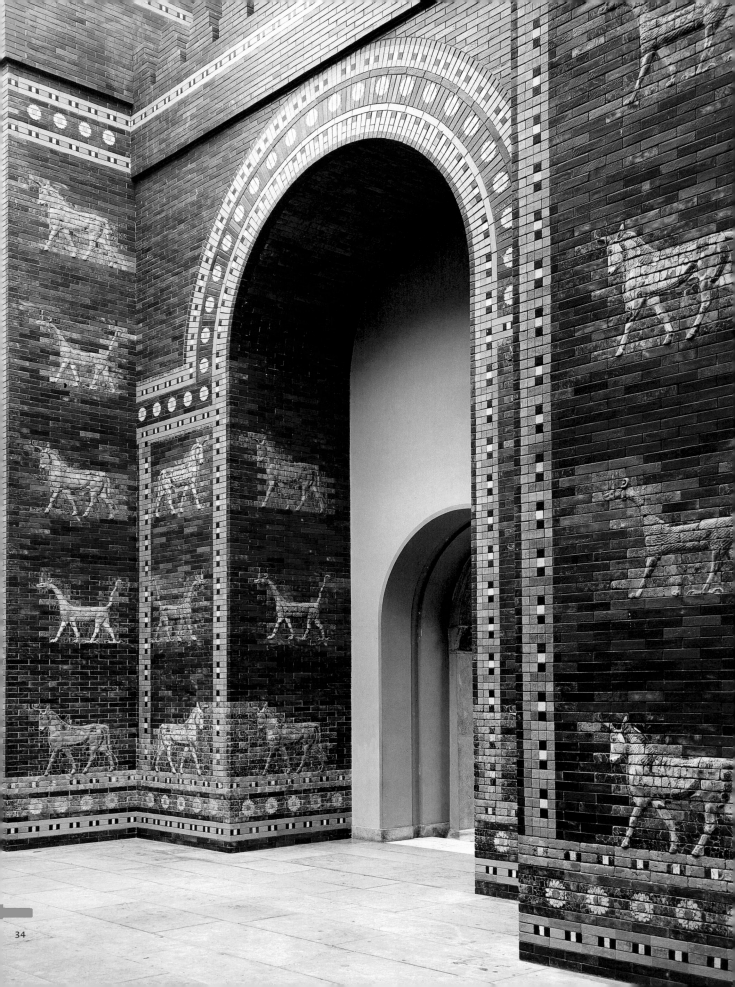

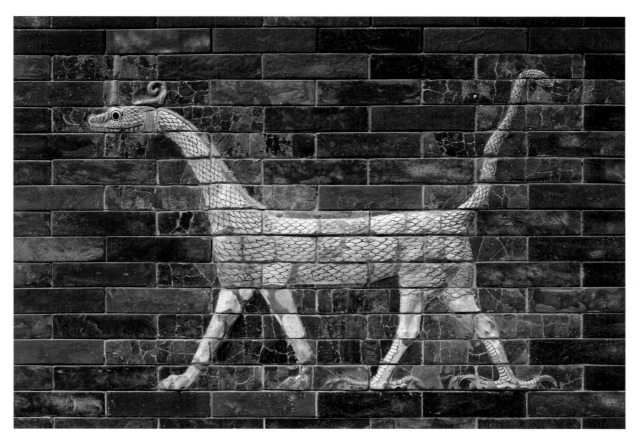

Ishtar Gate

Babylon, 6th century B.C.

The monumental Ishtar Gate was one of the city gates of Babylon, which was located in the region of modern Iraq. It was built under the reign of King Nebuchadnezzar II and ornamented in colored, glazed brick. The animal reliefs symbolize Babylonian deities – the bull for the storm god Adad, the dragon for their main god Marduk. The gate was named for Ishtar, the goddess of love and war.

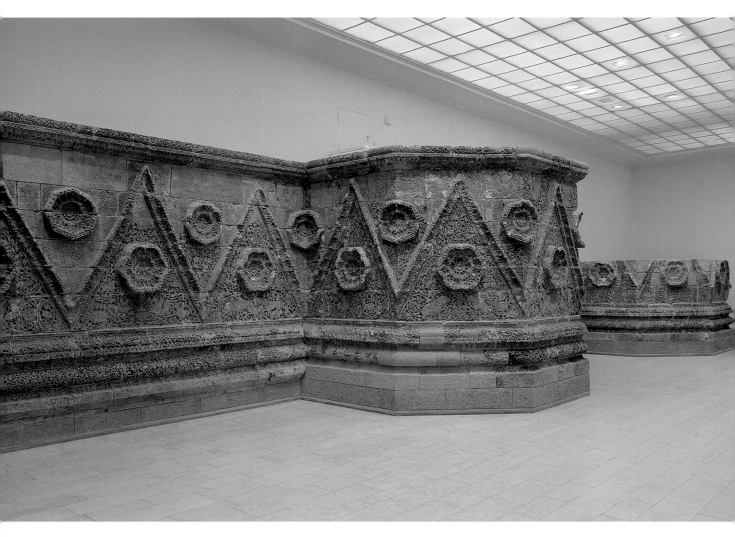

**Façade of the desert
palace Mschatta**
Jordan, c. 743

The façade formed the outer wall
of the residence of the caliph
Al-Walid II before the gates of the
modern Jordanian capital Amman.
Although the palace was not
yet completed by the 8th century,
the walls were already richly
decorated. The extremely ornate
limestone wall is encircled by
a zigzag pattern that includes
vines, birds, cattle, lions and grif-
fins above and below it.

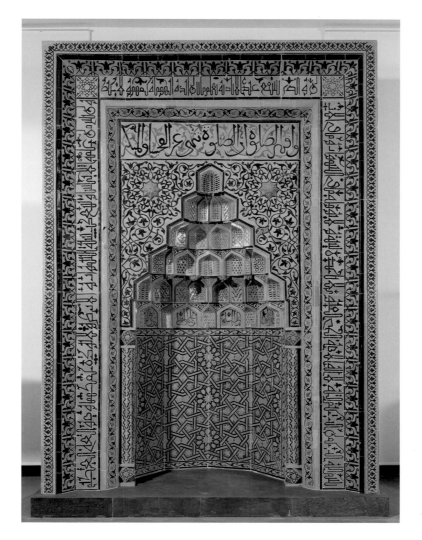

Mihrab (praying niche)

Beyhekim Mosque
in Konya (Turkey), after 1250

During prayer Muslims always align
themselves toward Mecca, the
burial place of Mohammed, who
founded the religion. Therefore,
every mosque has a prayer niche
showing the believer which direction
faces Mecca. The prayer niche from
Konya is an especially beautiful
example, richly decorated with
faience mosaics that include inscrip-
tions from the Koran, as is quite
traditional for such liturgical objects.

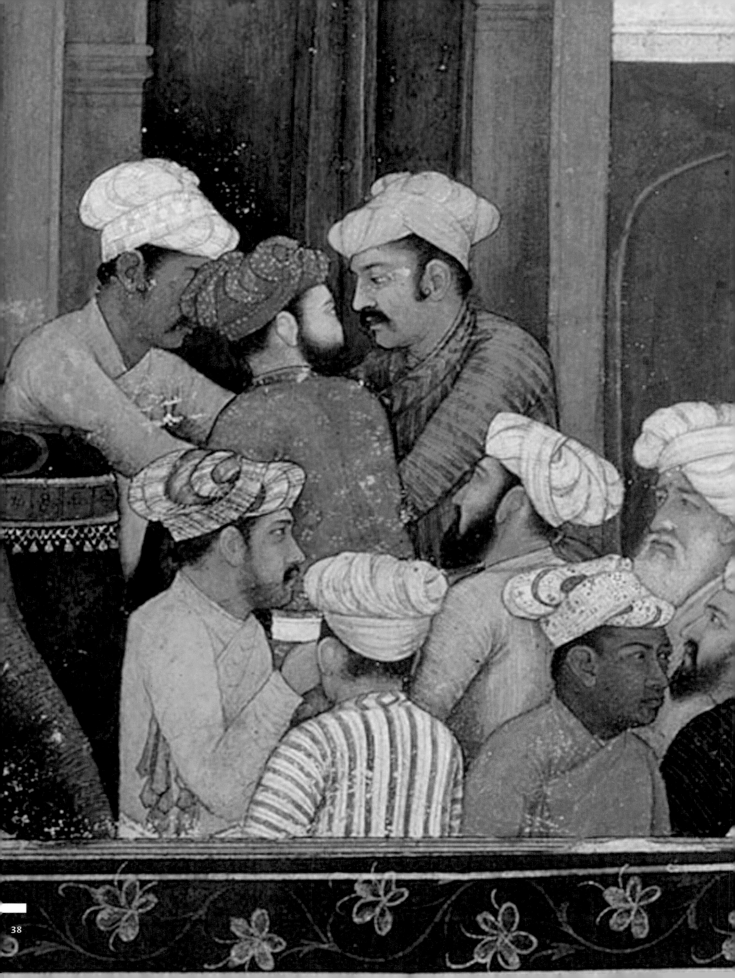

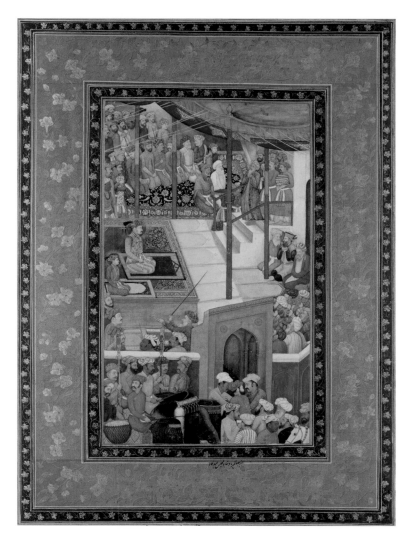

Daulat (?)

**The Emperor Jahangir
in a mosque**
Miniature painting, India, c. 1610

Together with his son kneeling to his right, the Indian emperor is depicted visiting a mosque at the conclusion of Ramadan, a month of fasting. Members of the royal court and dignitaries are shown standing and seated around them. They all listen to the words of the preacher standing on the stairs to the right. Many people have assembled before the gate of the mosque as well. The Indian miniature painting illustrates the high level of this art form under the rule of Jahangir.

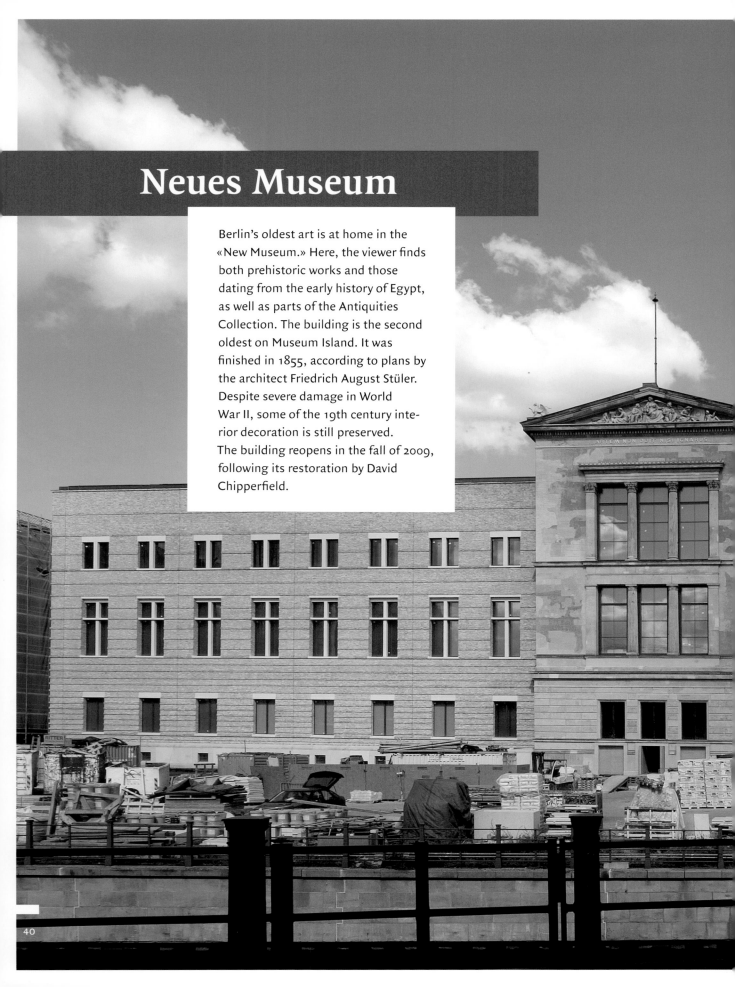

Neues Museum

Berlin's oldest art is at home in the «New Museum.» Here, the viewer finds both prehistoric works and those dating from the early history of Egypt, as well as parts of the Antiquities Collection. The building is the second oldest on Museum Island. It was finished in 1855, according to plans by the architect Friedrich August Stüler. Despite severe damage in World War II, some of the 19th century interior decoration is still preserved. The building reopens in the fall of 2009, following its restoration by David Chipperfield.

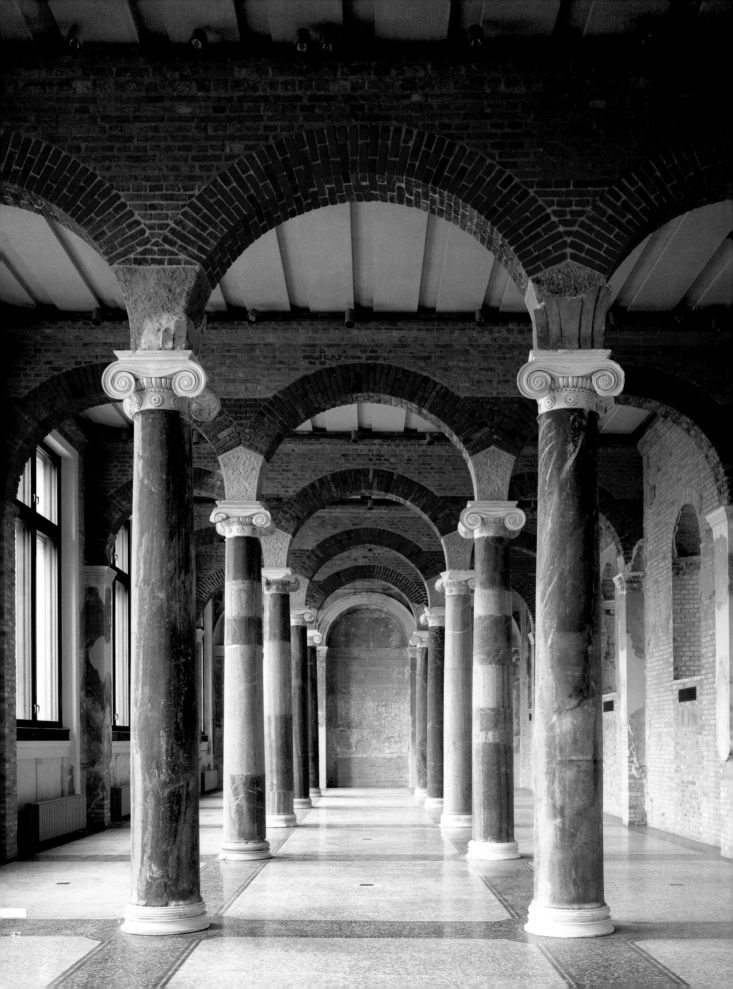

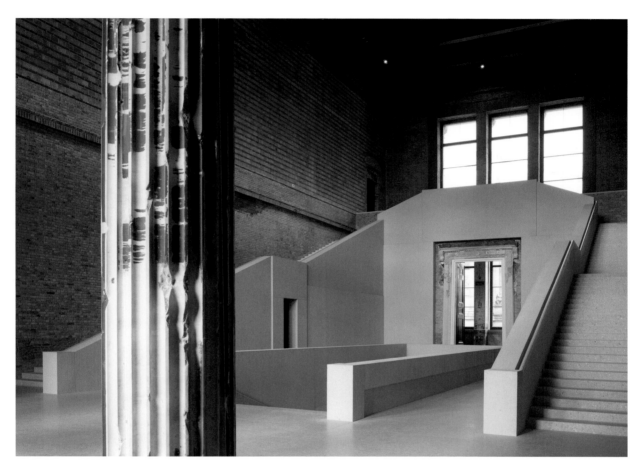

«Modern Hall» (left)

Originally, plaster casts of major works of sculpture from the Renaissance on were exhibited in the «Modern Hall.» Although the wall paneling and painted décor were destroyed in 1945, the original marble columns now make the hall one of the most beautiful interiors in the museum.

Stairwell (top)

The concept of the most recent restoration is especially striking in the stairwell. The remains of the original building were merely conserved, while nothing that was lost was reconstructed. This meant, for example, that the former colossal wall paintings were not recreated.

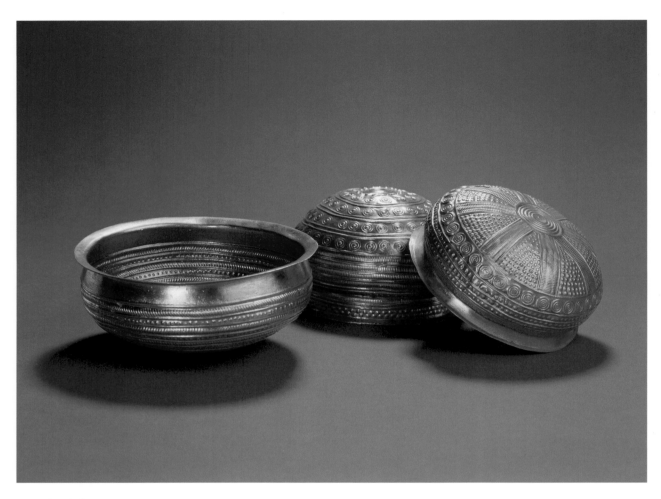

**Three bowls from
the Eberswalde Hoard**
c. 1000–700 B.C.
(copies made of gilded copper)

An earthenware vessel, in which
a total of 81 Bronze Age objects
made of gold were kept, was
found in 1913, one meter under
the ground in Eberswalde
(Brandenburg). The find included
vessels, gold ingots and jewelry.
The gold vessels are master-
fully designed in the repoussé
technique, combining ornamen-
tation of punched and stamped
patterning. The originals
have been in Moscow since 1945
as «looted art.»

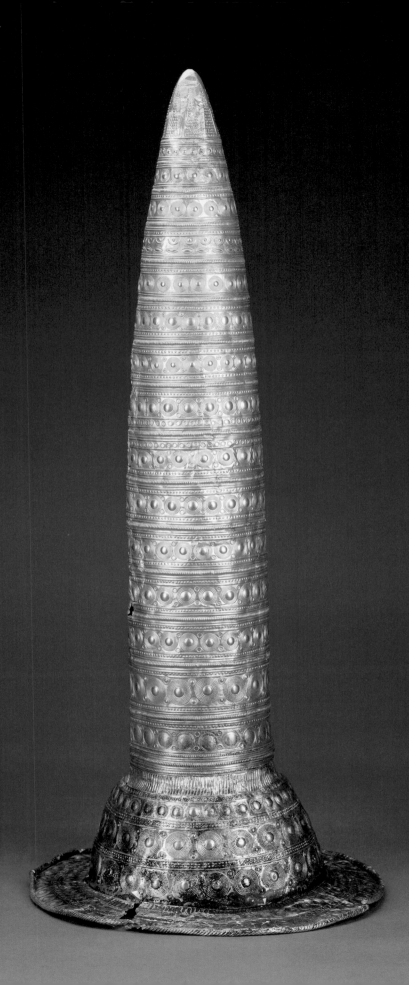

Berlin Gold Hat

c. 1000–800 B.C.

The 74 cm high gold hat,
created in a single piece, is
the world's largest and
best preserved example of
its kind. The ornamentation
can be interpreted as a cal-
endar and here the cycle of
the moon is represented.
Hats like this one are thought
to have been the ceremonial
headdresses of priest kings.
Alternatively, they may have
been the pinnacles of col-
umns used for cult purposes.

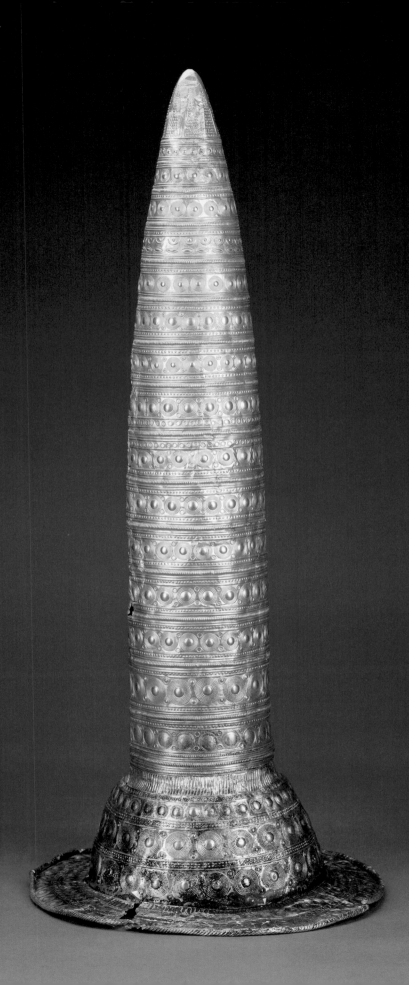

Neues Museum

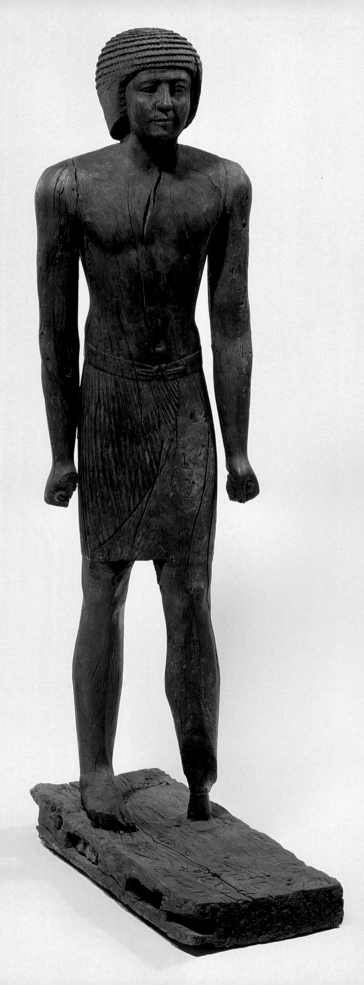

Statue of Perhernofret

Egypt, c. 2400 B.C.

The nearly life-sized wooden
figure depicts the typical
features of Egyptian standing/
striding figures, which the author
Thomas Mann described as
«standing while walking
and while standing walking.»
The figure was originally
covered with a thin layer of
stucco and painted. It belonged
to the décor of a grave site.
On the top side of its rectangu-
lar base is inscribed that it
portrays the «royal court subject
Perhernofret.»

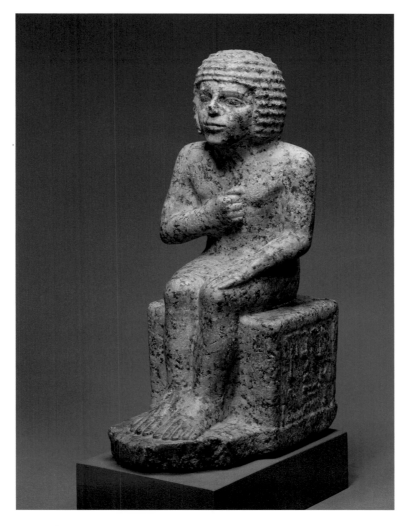

Seated figure of Methen
Egypt, c. 2600 B.C.

The Berlin Egyptologist
Richard Lepsius discovered
the block-like granite
figure in Abusir in the 1840s.
It was installed in a side
chamber of a fully preserved
mausoleum, decorated with
reliefs. Since this was
completely closed off to the
outside world, the seated
figure was not intended to be
observed, but served solely
to assist the dialogue bet-
ween the dead man and the
gods.

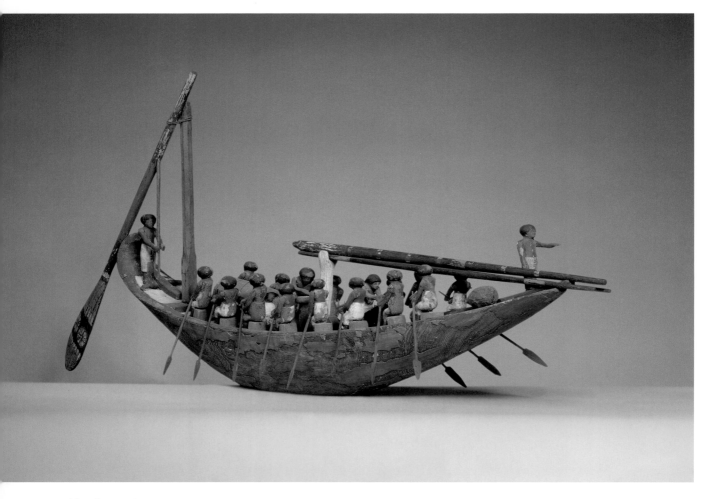

Ship of Mentuhotep

Egypt, c. 1900 B.C.

What looks like a toy ship was
found in the grave of the estate
manager Mentuhotep. Ships
have always belonged to the
objects placed in graves, because
the ancient Egyptians believed
that the deceased had to be
ferried to the holy burial place
of Osiris, the god of the afterlife.
Aside from its religious signif-
icance, however, this large row-
boat also provides an impression
of shipbuilding in a country
in which the Nile was the most
important route of transportation.

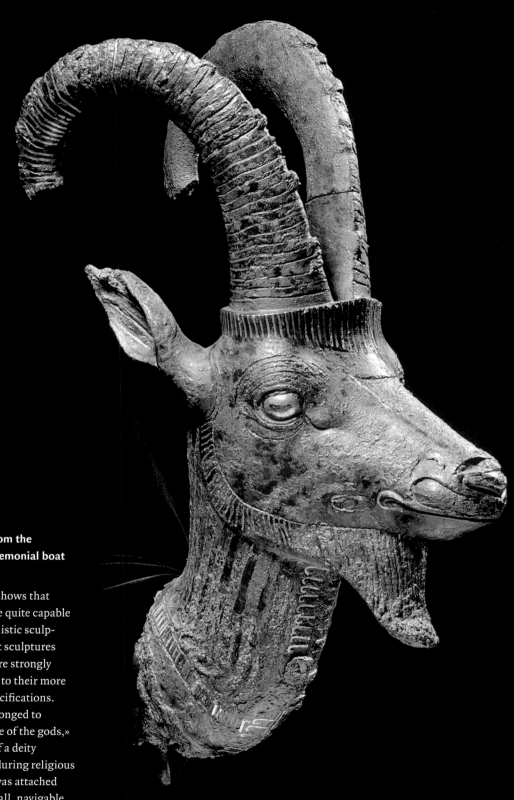

Head of an ibex from the bow of a small ceremonial boat
Egypt, c. 1000 B.C.

This bronze head shows that the Egyptians were quite capable of creating naturalistic sculptures. The fact that sculptures of people were more strongly formalized attests to their more severe stylistic specifications. The ibex either belonged to a so-called «barque of the gods,» in which images of a deity were transported during religious ceremonies, or it was attached to the bow of a small, navigable, processional row boat.

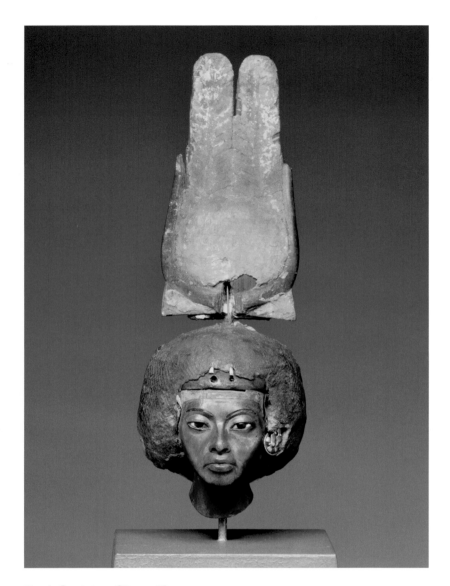

Head of a statue of Queen Tiye

Egypt, c. 1355 B.C.

The head of Tiye is one of the oldest individual portraits in the history of art. Tiye's life was no less exceptional than her portrait, which speaks of intelligence and life experience. Although she came from an ordinary Egyptian family, she became the wife of the Pharaoh Amenhotep III. Ultimately, Nefertiti's mother-in-law was raised to the level of goddess, as is indicated by the goddess' crown that Tiye wears on her head.

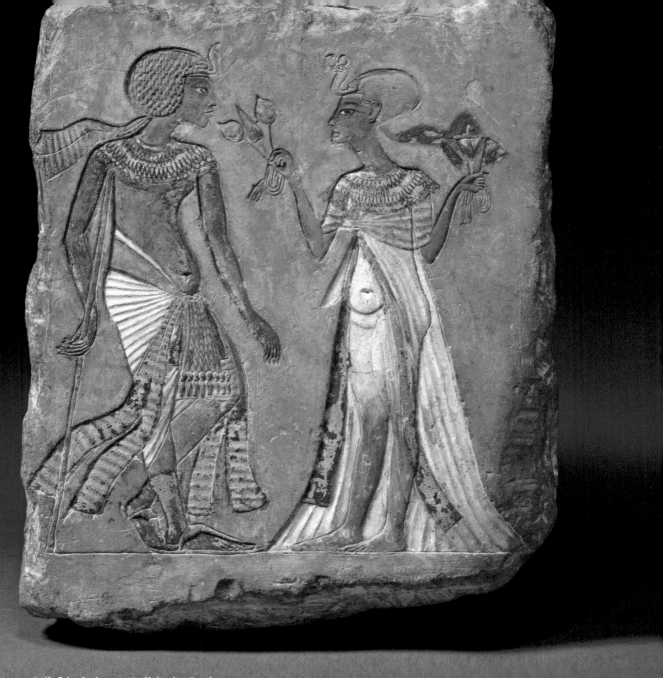

Relief depicting a «Walk in the Garden»
Egypt, c. 1330 B.C.

The enchanting relief shows a stylishly
dressed young couple during a rendezvous.
The man leans on a staff in a casual pose,
while the woman holds fragrant flowers
out to him. Nefertiti's daughter and son-in-
law are likely represented.

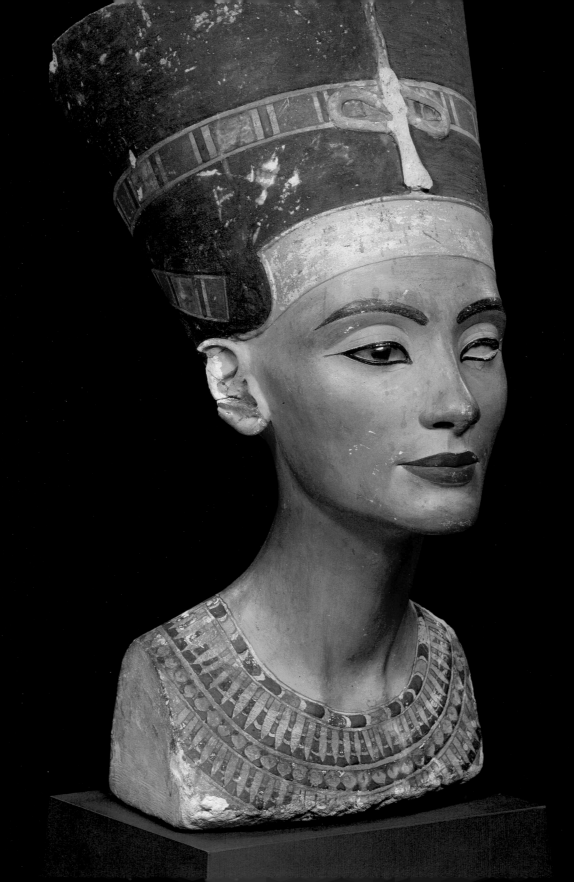

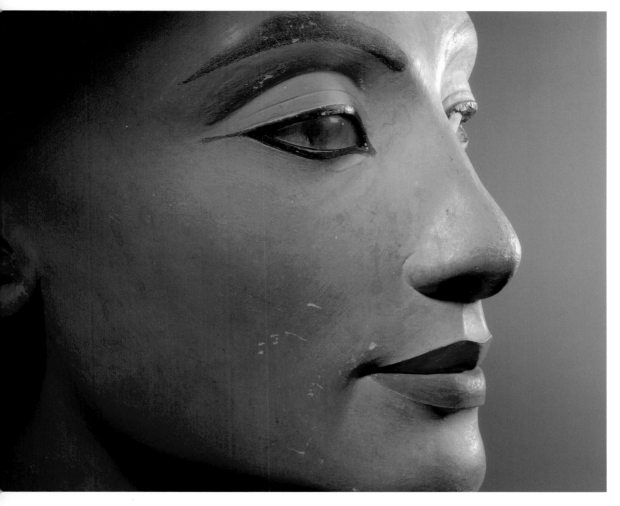

Bust of Nefertiti

Egypt, 1338 B.C.

«Nefertiti» is probably the
most famous work of art on
Museum Island. The Egyptian
beauty was the wife of the
Pharaoh Akhenaten. This head
with its well-proportioned
features never left the workshop
of the sculptor Thutmose,
where it presumably served as
a model for further busts. It was
discovered in Amarna in 1912.
After residing at various loca-
tions in Berlin, the statute
is returning to its former home
at the Neues Museum in 2009.

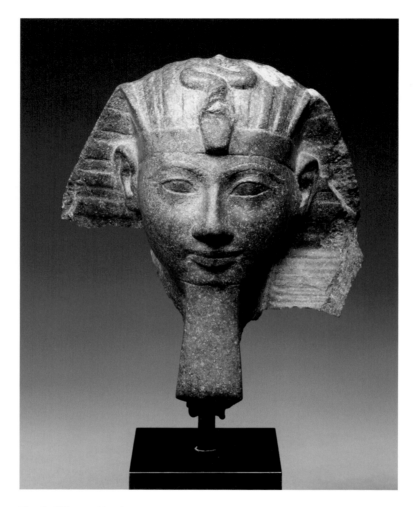

Head of Queen Hatshepsut
Egypt, c. 1475 B.C.

Hatshepsut was one of the
few women to rule autonomously
in ancient Egypt. She appears
more like a young man here, be-
cause of the artificial, ceremo-
nial beard she is wearing that was
typical among the pharaohs.
After Hatshepsut's death, her step-
son and successor Thutmose III
attempted to obliterate her memo-
ry, because he could not forgive
her for keeping him away from the
throne until her death. To this
end he had this head cut off the
statue to which it once belonged.

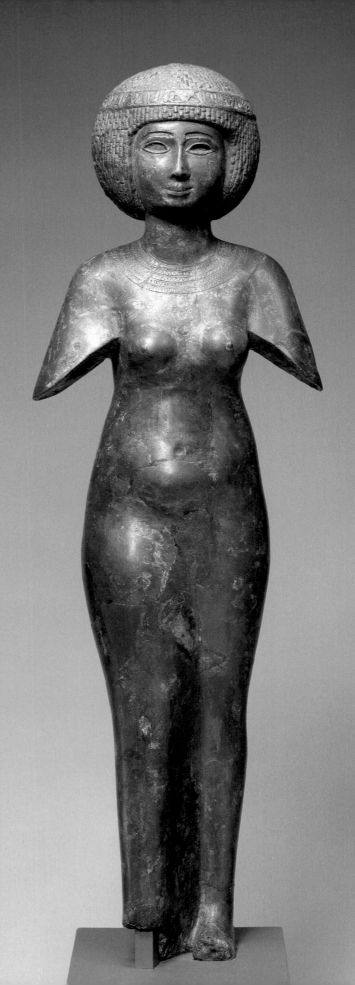

**Standing figure of
the priestess Meresamun**
Egypt, 875–837 B.C.

An inscription on the figure's
right, wing-like sleeve reveals
the identity of the graceful
young woman. Meresamun
was a «singer at the Temple of
Amun» in Karnak. She wears
a balloon-like wig crowned
by a diadem. The shape of her
body stands out considerably
under her skintight gown.
Although the figure's arms are
lost, presumably she would
have held a musical instrument
in her hands.

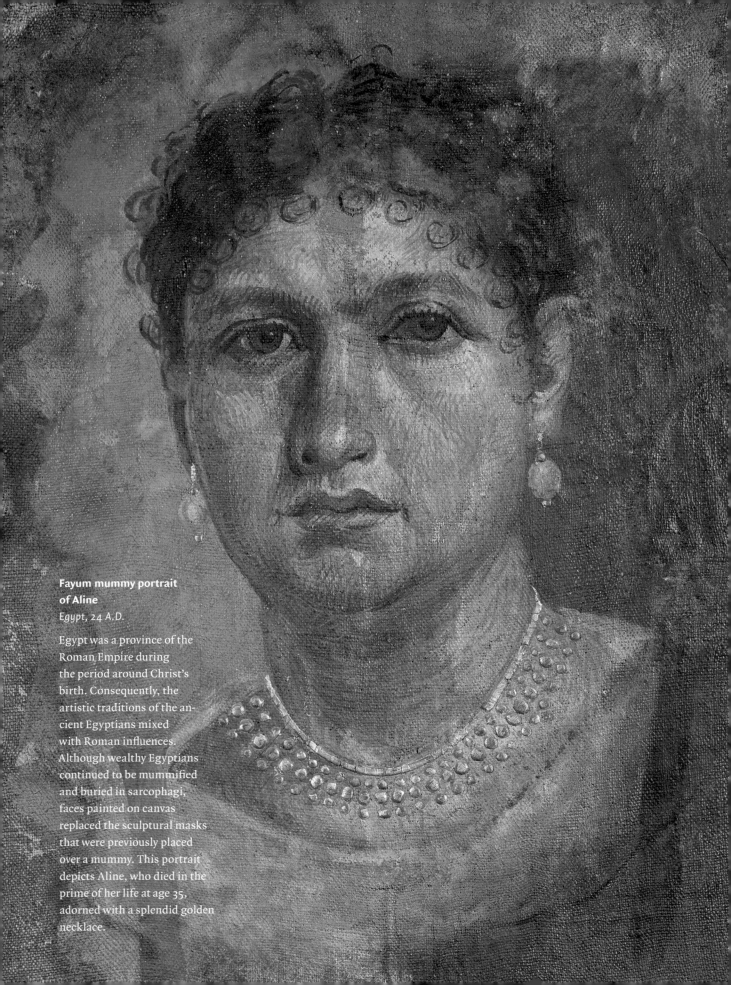

**Fayum mummy portrait
of Aline**
Egypt, 24 A.D.

Egypt was a province of the
Roman Empire during
the period around Christ's
birth. Consequently, the
artistic traditions of the an-
cient Egyptians mixed
with Roman influences.
Although wealthy Egyptians
continued to be mummified
and buried in sarcophagi,
faces painted on canvas
replaced the sculptural masks
that were previously placed
over a mummy. This portrait
depicts Aline, who died in the
prime of her life at age 35,
adorned with a splendid golden
necklace.

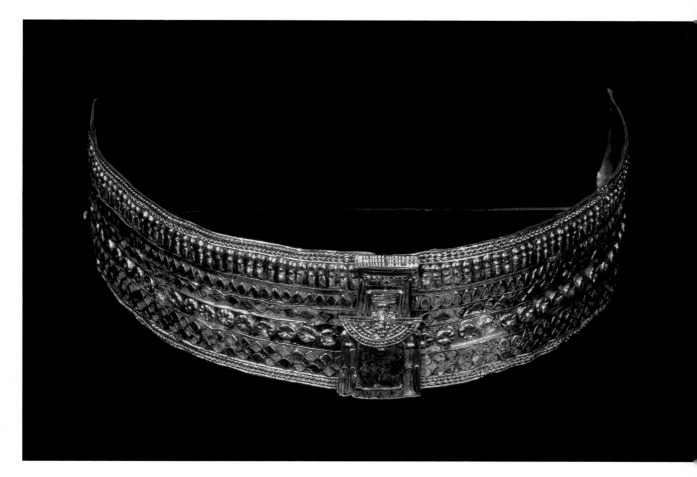

Arm bracelet
of Queen Amanishakheto
Sudan, 10 B.C.

This precious piece of jewelry,
made of gold inlaid with
fused glass, was found in 1834
in one of the pyramids of
Meroe (in modern Sudan), the
capital of the independent
«Kingdom of Kush.» It was
a burial offering that belonged
to Amanishaketho, the king's
powerful mother. Throughout
her lifetime, the empire was
at war with the Romans. The
influence of Hellenistic jewelry
from the period can clearly be
seen in the bracelet.

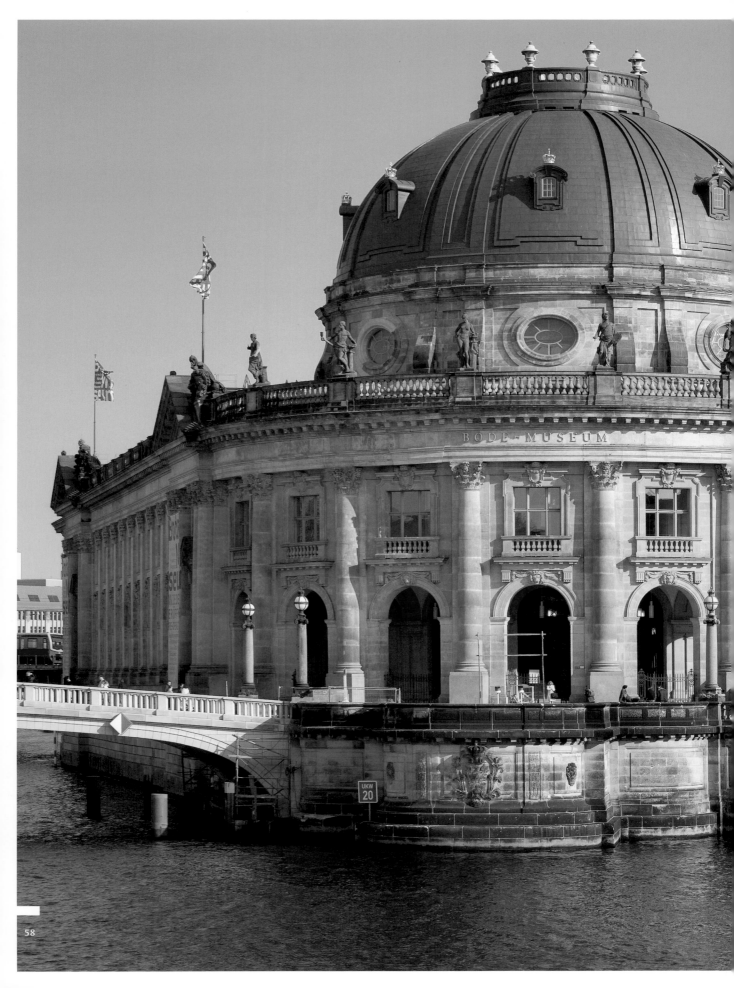

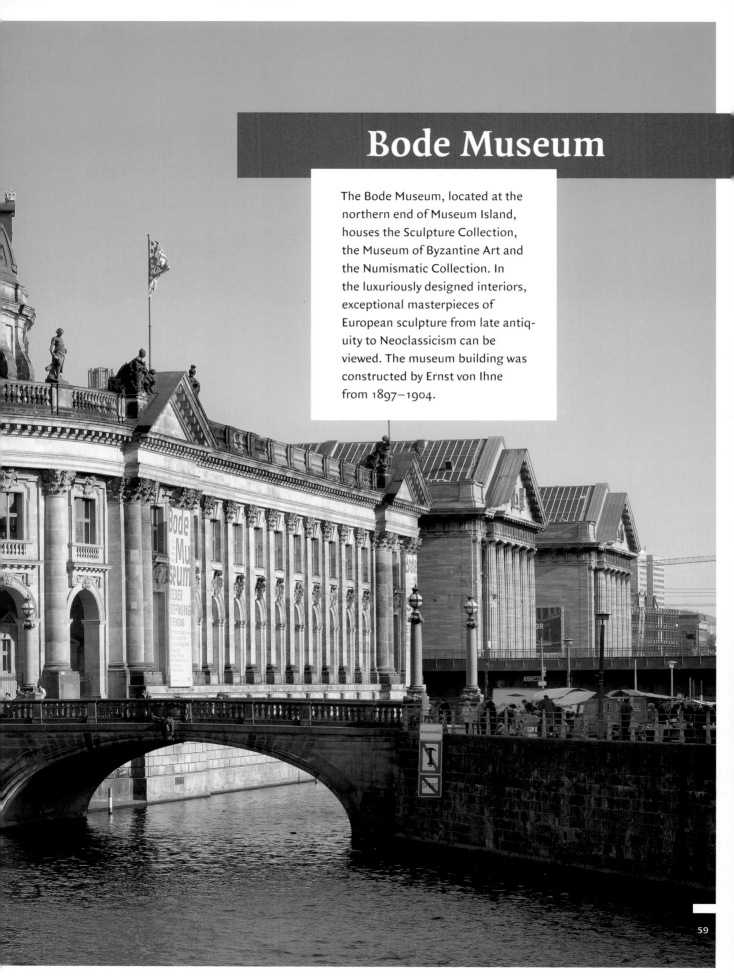

Bode Museum

The Bode Museum, located at the northern end of Museum Island, houses the Sculpture Collection, the Museum of Byzantine Art and the Numismatic Collection. In the luxuriously designed interiors, exceptional masterpieces of European sculpture from late antiquity to Neoclassicism can be viewed. The museum building was constructed by Ernst von Ihne from 1897–1904.

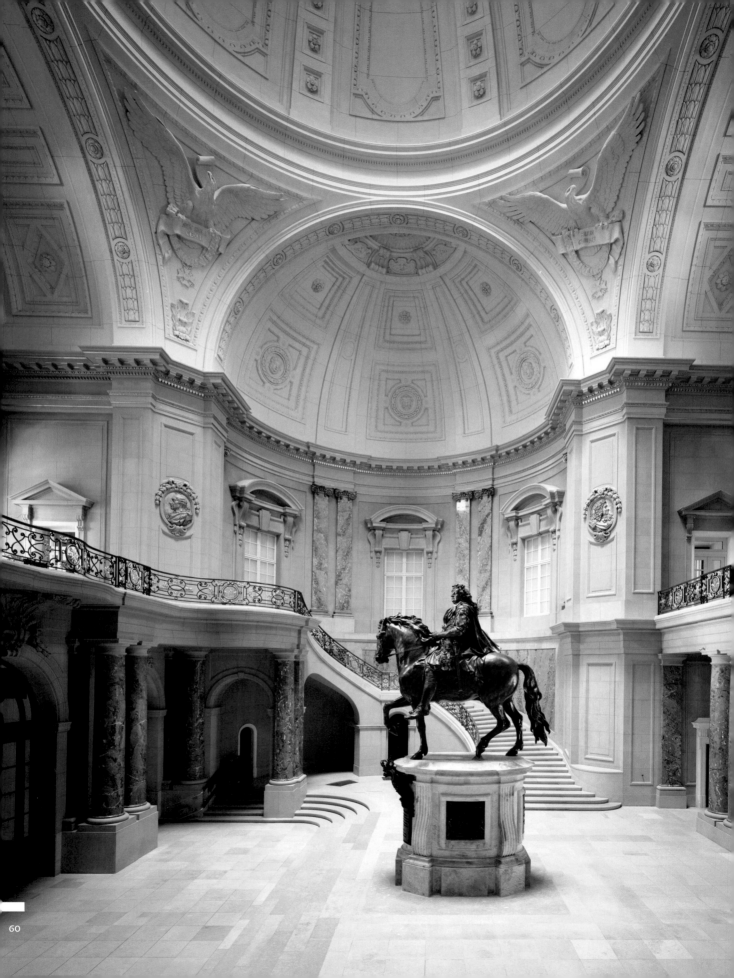

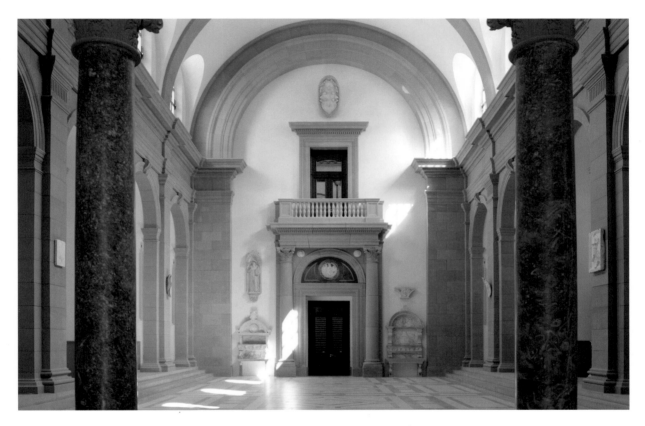

Entrance hall *(left)*

The large entrance hall is reminiscent of a palace festival hall or of a Baroque church. At the center is an equestrian statue of the Great Elector by Andreas Schlüter from 1700. It is not only this work, but also the golden medallions on the walls that make reference to the Prussian rulers.

«Basilica» *(top)*

The «Basilica» still exemplifies the original concept of the museum, where the style of architecture was intended to match the works exhibited.

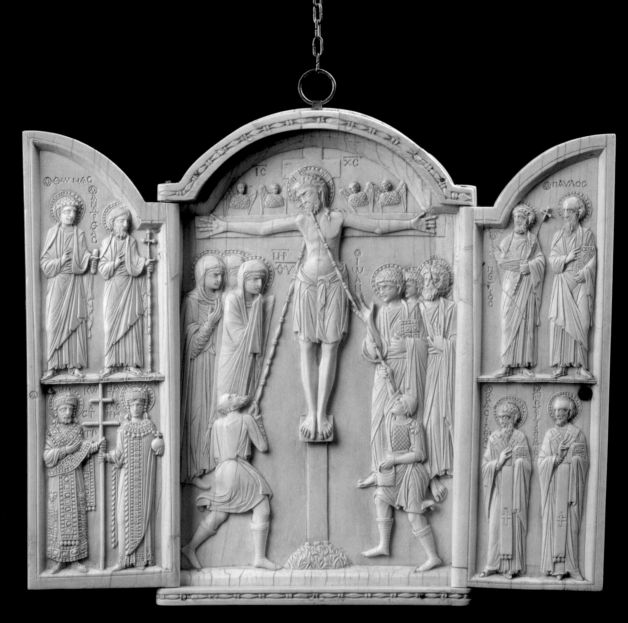

Small winged altarpiece made of ivory depicting the crucifixion
Constantinople, 11th century

Two Roman soldiers humiliate Christ, who is suffering on the cross: the first holds out a sponge soaked in vinegar to the thirsting man, while the other inflicts a wound into his side with a spear. The scene is flanked to the left and the right by the Virgin Mary, some of the apostles and saints, all shown with solemn expressions. Small ivory altarpieces like this one were used for private devotion and could be taken along on a journey.

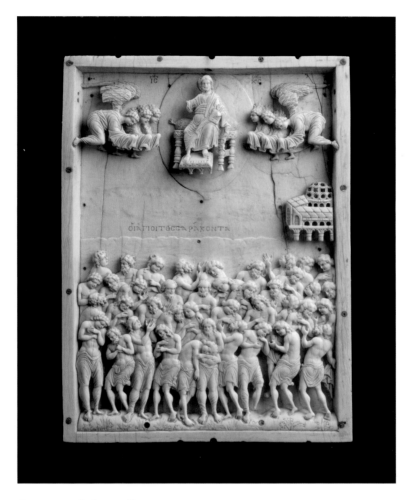

**Center panel of a small,
tripartite winged altarpiece made
of ivory that depicts the Forty
Martyrs of Sebaste**
Constantinople, 10th century

According to the cruel legend, forty
soldiers who adhered to Christianity
during the 4th century were sent
into a frozen pond to freeze to death.
Only he who renounced his faith
might save himself and go into the
heated bathhouse represented to the
right. However, with one exception,
the group remained steadfast
and froze to death. Christ, who sits
enthroned above the scene, will
reward them for their martyrdom
in heaven.

**Angel from the grave
of a saint**
Cologne, c. 1170

This figure with a soulful
facial expression originates
from a church in Cologne.
The city on the Rhine was
one of the centers of Ro-
manesque art in Germany.
The angel originally belonged
to a group of figures repre-
senting the miracle of Christ's
resurrection. When the
women come to Christ's grave
on Easter Sunday, the body
has disappeared. The angel
reveals to them an incredible
event: «He isn't here! He has
risen from the dead.»

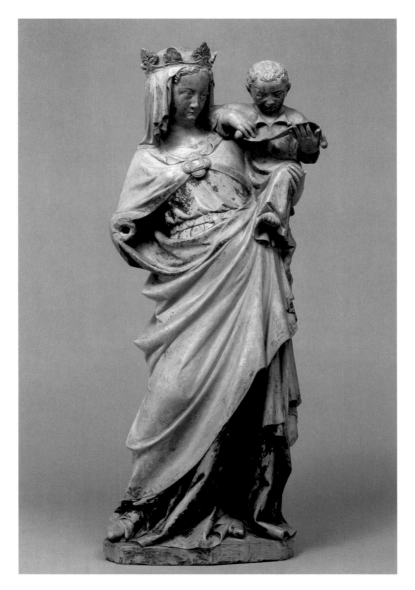

Mother of God

Lorraine, c. 1290

On her arm a courtly and
elegantly dressed Virgin Mary
carries the Christ Child, who
reads a scroll. Full of earnest-
ness, her gaze is cast into
the distance as if she is con-
scious of her son's tragic
fate. Vestiges of the former col-
oration can be perceived on
her gown. The figures are an
excellent example of the
mastery of Gothic sculptors
in France.

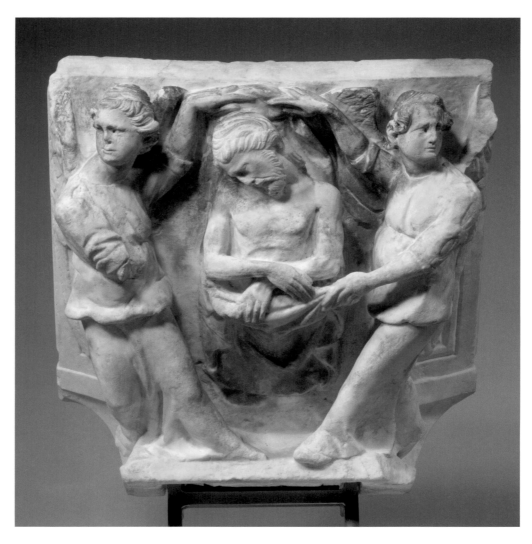

GIOVANNI PISANO

Angel Pietà

Tuscany, c. 1300

The sculptor Giovanni Pisano, aka Giovanni of Pisa, created two well-known Italian pulpits; one in Pistoia and one in Pisa. It is not known to which of the two pulpits this pietà once belonged. Wrapped in a shroud, Christ is flanked by two angels. Pisano has masterly portrayed the maltreated body of Christ and the angels forlornly looking away. The ledge atop the pulpit served as a lectern for holding the Bible.

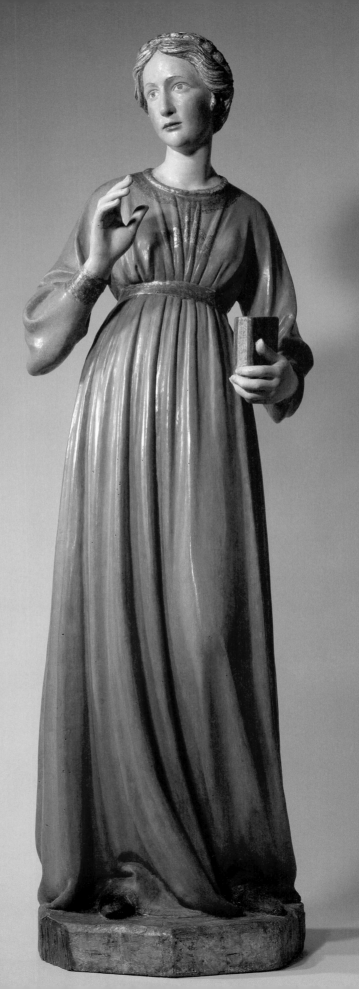

FRANCESCO DI VALDAMBRINO

**The Virgin Mary from
an Annunciation scene**
Tuscany, c. 1420

Reacting to a lost correspond-
ing angel, the Virgin Mary
stops short, awestruck,
responding to the announce-
ment that she will give birth
to Jesus Christ, the son
of God. Her facial expression
and gestures are reminis-
cent of those of an actress on
stage. During the 15th
century in Italy, such figures
were often set up in the
middle of a church to make
the Christian story more vivid
for believers.

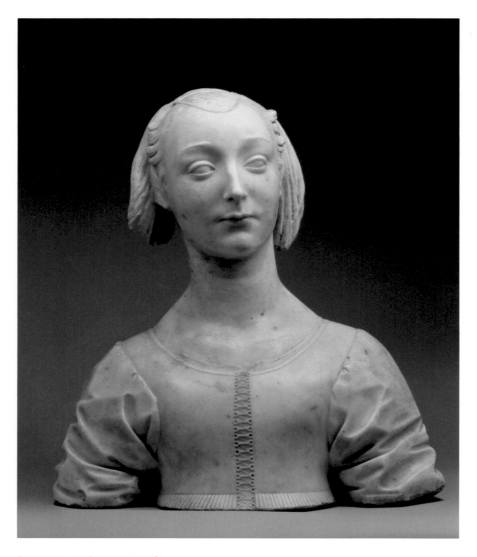

Desiderio da Settignano (?)

Portrait of a Young Woman
Florence, c. 1460

It is not known with certainty
which sculptor immortalized
the sassy beauty in stone.
Much speaks for the fact that
it was the Renaissance sculp-
tor Desiderio da Settignano and
that the girl is Marietta Strozzi.
The Strozzis were one of the
richest families in Florence. The
bust may have been created
in order to help find her a hus-
band. Or perhaps the sculpture
was set up by her parents as
a remembrance of their married
daughter.

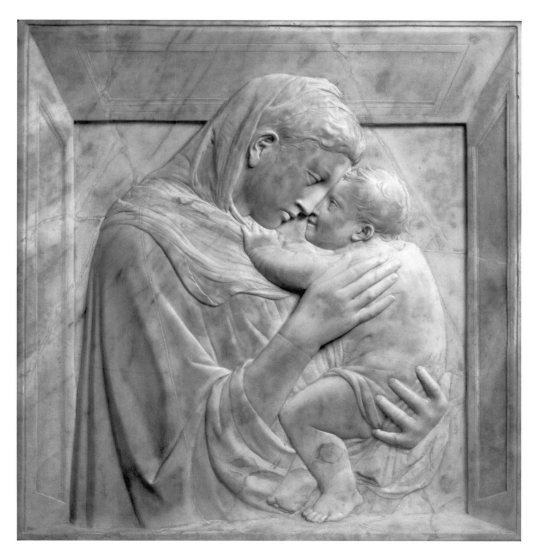

DONATELLO

Madonna Pazzi

Florence, c. 1420

Donatello, the most impor-
tant sculptor of the early Italian
Renaissance, concentrates
completely on the relationship
of mother and child, which
he represents in an intimate ex-
change that was new for the
period. At the same time the artist
also wants to stress to the viewer
that it is not just any child,
but the son of God to whom the
mother turns her attention.
Moreover, the bas-relief attests
to Donatello's excellent mastery
of perspective.

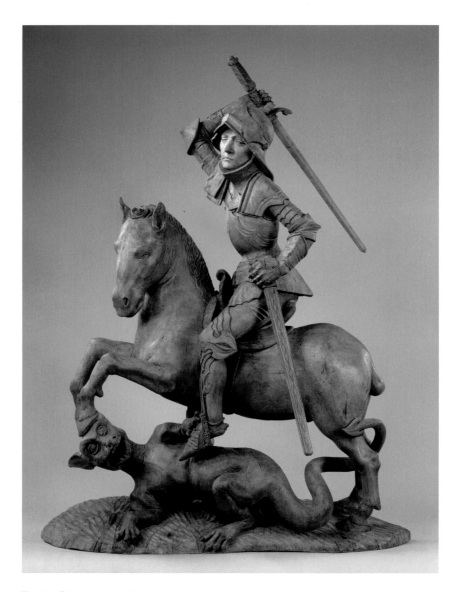

Tilman Riemenschneider

St. George and the Dragon
Würzburg, 1490

According to legend, St. George
killed a dragon and saved the
daughter of a king from its claws.
Riemenschneider's represen-
tation of the scene belongs to the
most impressive examples of
this archetypal story depicting
a fight between good and evil.
The late Gothic Franconian wood
carver was so talented that
he chose not to have his figures
painted. Instead, his mastery
in handling the limewood
was intended to stand on its own.

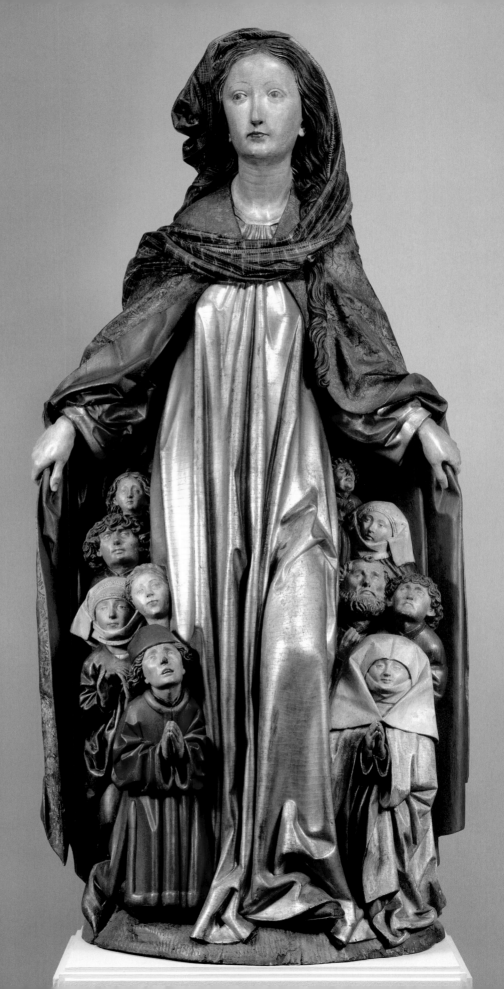

MICHEL ERHART OR
FRIEDRICH SCHRAMM

**Madonna with
the Protective Cloak**
Ravensburg, c. 1480

Under the cloak of the
Mother of God all social
levels of the population
are assembled, asking
for her protection.
The figures are dressed
in a style from the end
of the 15th century.
The late Gothic sculpture
is from the Ravensburg
town church, not far from
Lake Constance. To this
day it has not been estab-
lished which of the two
employees of the Ulm wood
carver Jörg Syrlin was
responsible for this work.

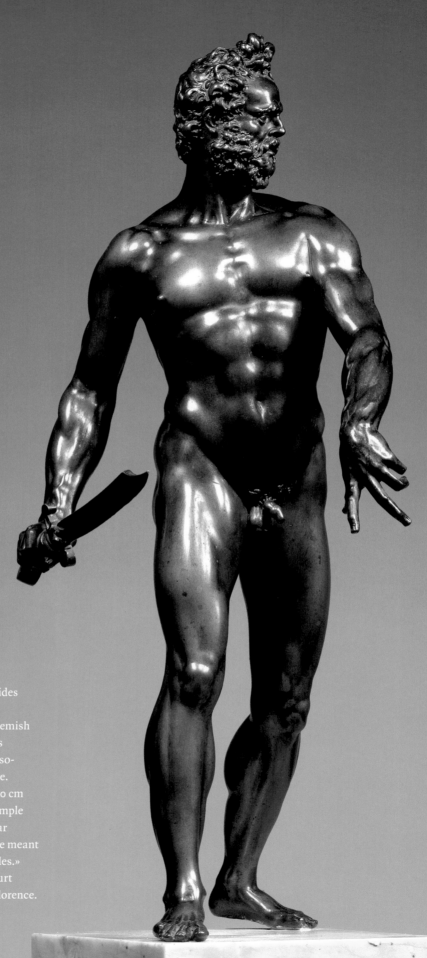

GIOVANNI BOLOGNA

Mars Gradivus
Florence, c. 1580

The classical god of war strides
forwards into a fight, both
elegant and forceful. The Flemish
sculptor has bestowed Mars
with a typically Mannerist, so-
phisticatedly turned posture.
The figure, approximately 40 cm
high, is an outstanding example
of the small bronzes popular
in the 16th century that were meant
to be «beautiful from all sides.»
Giovanni Bologna was a court
sculptor for the Medici in Florence.

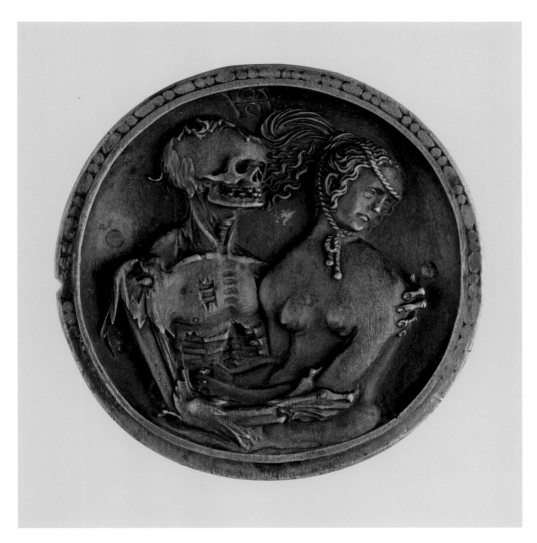

Hans Schwarz

Death and the Maiden
Swabia, c. 1520

Like a lover, a personification of Death draws the naked beauty to himself. Beauty and youth are transient and death is inevitable in the end. The medallion calls upon the viewer to lead a meaningful life. Although the relief is only half a centimeter deep, Schwarz (a Renaissance sculptor from Augsburg) has succeeded in confronting us with an extremely three-dimensional portrayal of the sinister skeleton and the young woman.

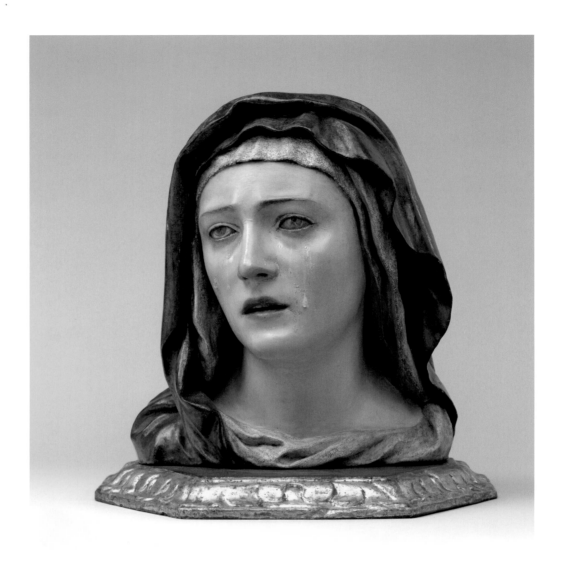

PEDRO ROLDÁN (?)

Mater Dolorosa

Spain, c. 1670–75

This bust of a weeping Virgin
Mary is almost shocking in its real-
ism. Her skin is pale, her eyes
are full of grief and even tears
(of glass) run down the cheeks of
Christ's mother. Roldán complied
with a widespread, typically
Baroque demand for devotional
figures at that time, which
were intended to encourage a view-
er's emotions and compassion.
Those praying should have the
feeling that the Virgin Mary was
standing right in front of them and
could hear their prayers.

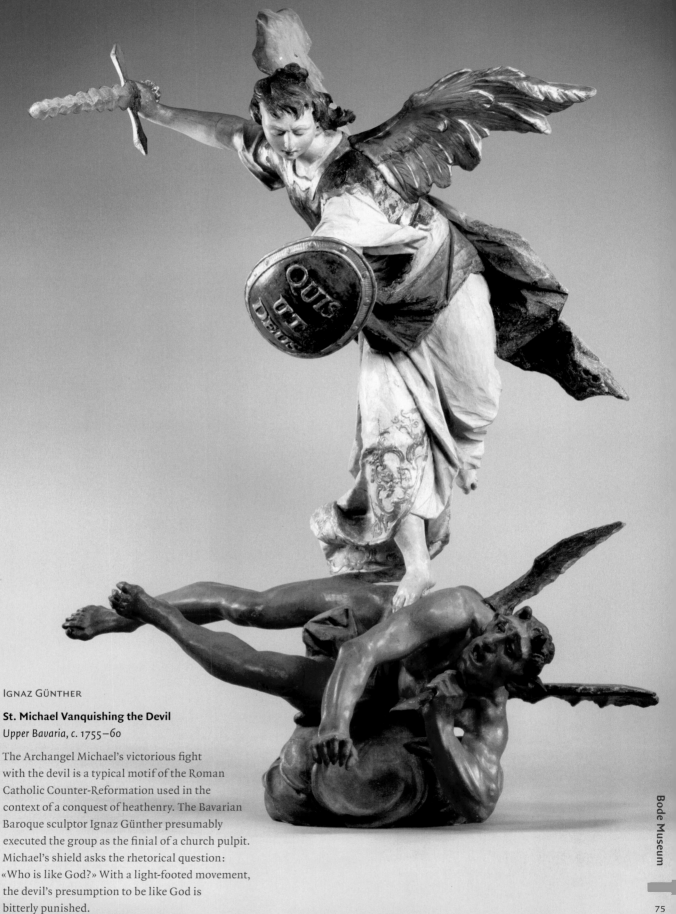

Ignaz Günther

St. Michael Vanquishing the Devil
Upper Bavaria, c. 1755–60

The Archangel Michael's victorious fight
with the devil is a typical motif of the Roman
Catholic Counter-Reformation used in the
context of a conquest of heathenry. The Bavarian
Baroque sculptor Ignaz Günther presumably
executed the group as the finial of a church pulpit.
Michael's shield asks the rhetorical question:
«Who is like God?» With a light-footed movement,
the devil's presumption to be like God is
bitterly punished.

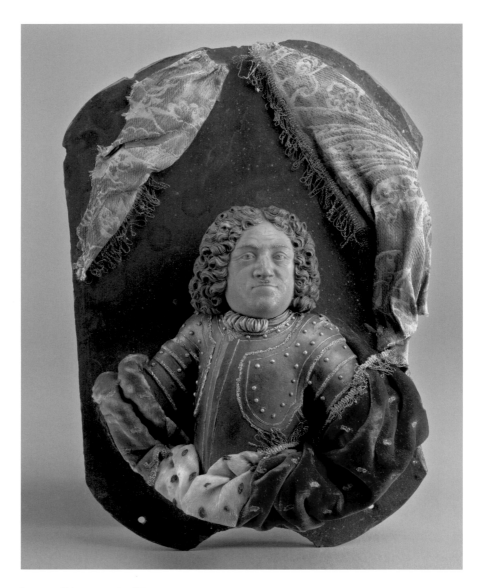

Johann Wilhelm von Kolm

Frederick III, Elector of Brandenburg

Berlin, c. 1700

The wax portraits of the Baroque era
were early precursors of the figures
in Madame Tussaud's wax museum.
Even at that time deceptively true-
to-life resemblances were in demand
so that the Prussian «court wax
modeler» von Kolm could replicate his
sovereign with a realism that seems
almost unkind today, right down to
the elector's beard stubble. The use of
diverse materials – to meticuously
imitate even the clothing of the man
who would later become Prussia's
first king – is also characteristic.

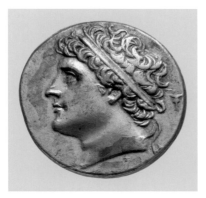

Hieron II

3rd century B.C.

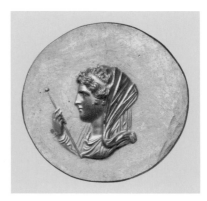

**Olympias,
mother of Alexander the Great**

3rd century B.C.

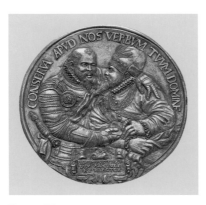

Tobias Wolf

**Augustus I, Elector of Saxony and
John George, Elector of Brandenburg**

1577

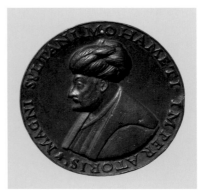

copy after Gentile Bellini

Sultan Mehmed II

c. 1480

**Elector Frederick III of Brandenburg
and his wife Sophie Charlotte**

late 17th century

Alexander von Humboldt

1828

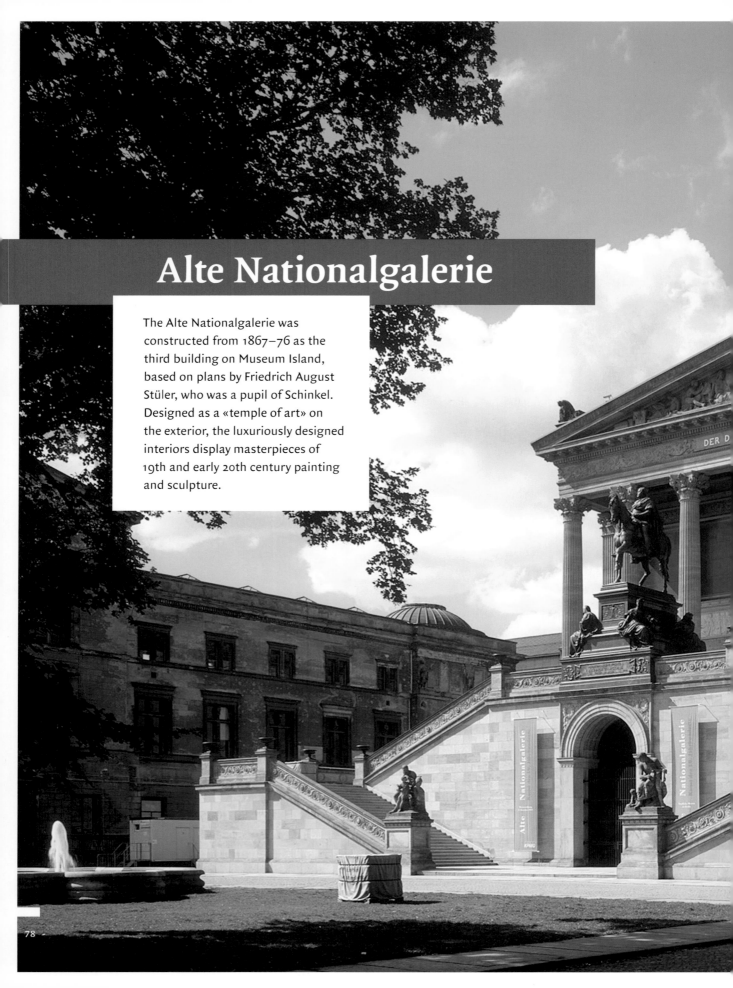

Alte Nationalgalerie

The Alte Nationalgalerie was constructed from 1867–76 as the third building on Museum Island, based on plans by Friedrich August Stüler, who was a pupil of Schinkel. Designed as a «temple of art» on the exterior, the luxuriously designed interiors display masterpieces of 19th and early 20th century painting and sculpture.

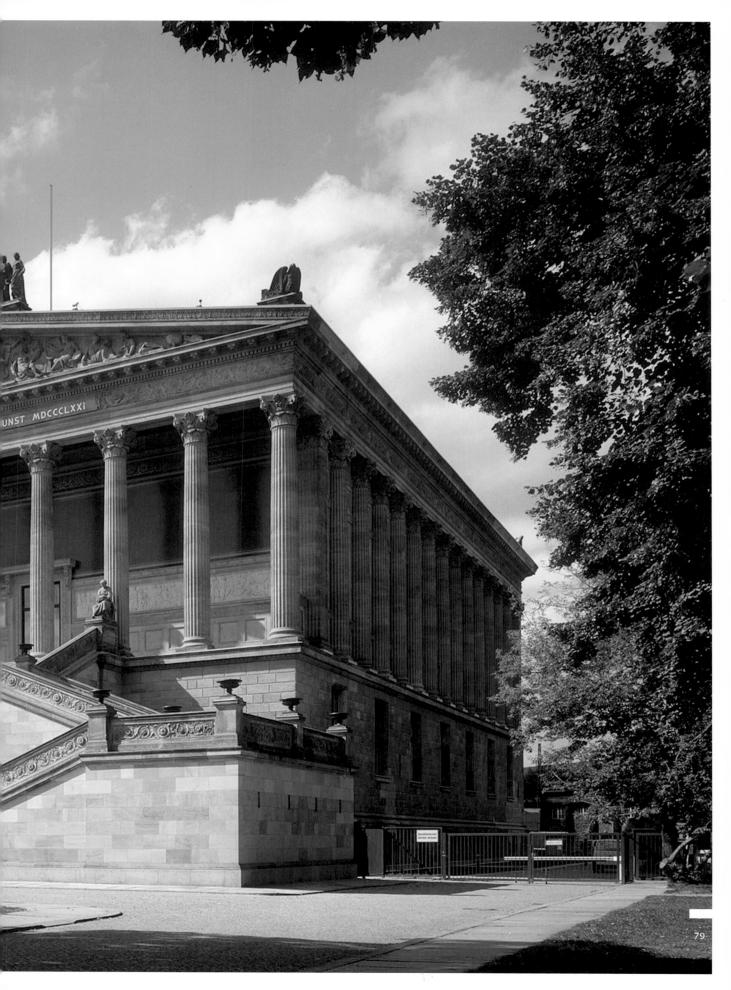

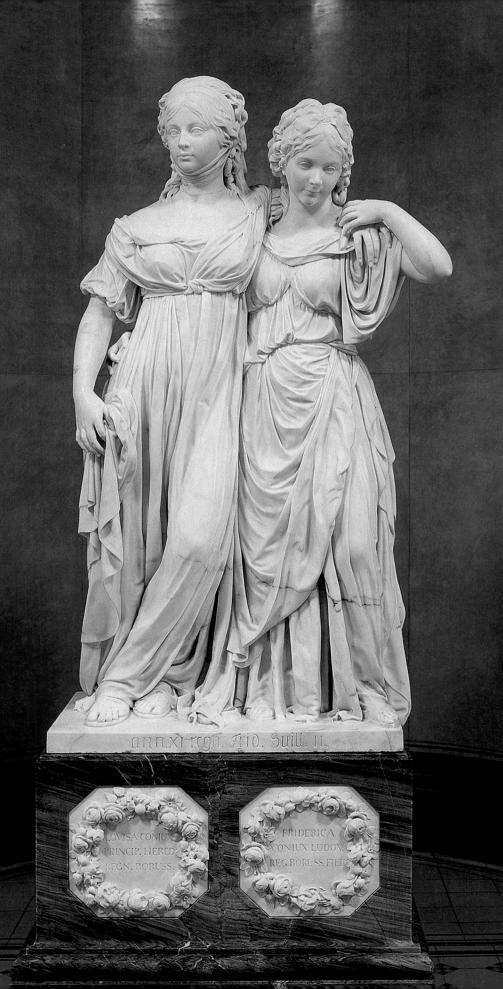

JOHANN GOTTFRIED SCHADOW

Crown Princess Louise and Princess Frederica of Prussia
1795–97

This major work of Berlin Neoclassicism portrays two beautiful princesses – Louise, later queen of Prussia, and her younger sister Frederica. Louise's husband, the king of Prussia, was not fond of the statue. The life-like naturalness of the figural group disturbed him and he dismissed it with few words: «To me, it's fatal.» The sculpture was first installed here after 1945 and it is now one of the most popular works in the museum.

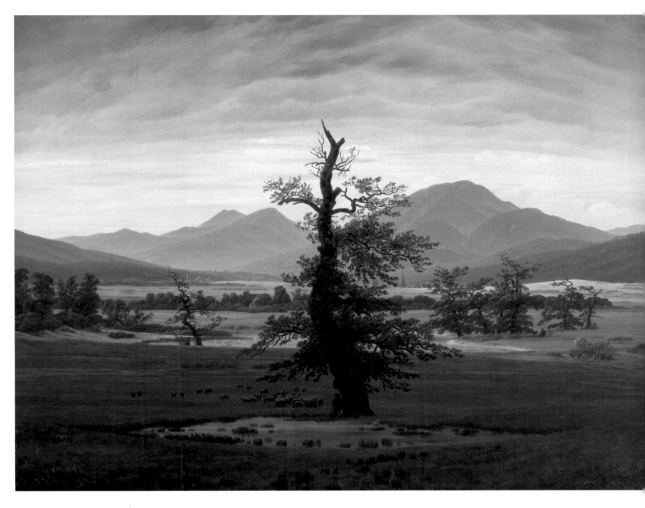

CASPAR DAVID FRIEDRICH

The Lone Tree
1822

This painting is one of the major works by the most important painter of German Romanticism. A monumental oak ruffled by the wind rises over the plains, directly at the center of the canvas. At that time, it was still unusual to make a tree the subject of a large painting. Friedrich consciously left the symbolic meaning open. The tree may be interpreted as either a national or even a religious symbol.

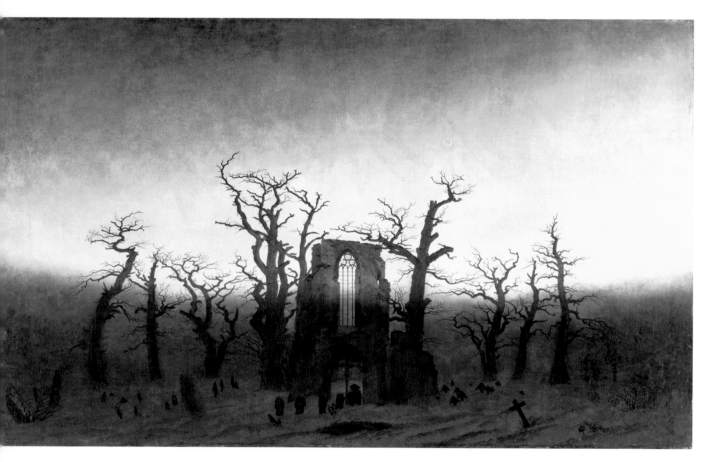

CASPAR DAVID FRIEDRICH

The Abbey in the Oak Wood

1809–10

The ruin of a Gothic church
is set in a desolate, wintry oak
forest. The sun has just set
as several monks carry a casket
across the cemetery to the
church portal to say mass for the
dead man. The light in the
sky may be understood as an
expression of the hope for a life
in the hereafter. Together
with its counterpart, «Monk by
the Sea,» Friedrich's image is
a key work of Romantic landscape
painting.

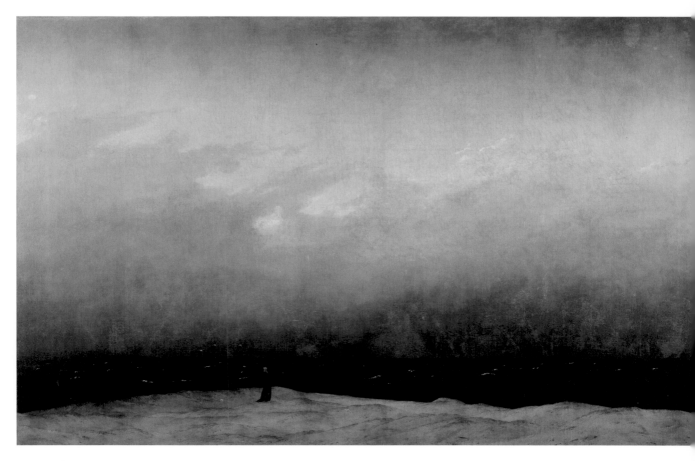

CASPAR DAVID FRIEDRICH

Monk by the Sea

1808–10

A monk stands alone on a wide, bare beach, before him the infinite sea, above him a cloud-covered sky. The tripartite composition seems almost abstract, which is why the work has often been interpreted as a prelude to Modernist painting. The poet Heinrich von Kleist was the first to describe the painting's radicalism, which he compared to a viewer having his «eyelids cut away.» Nothing distracts us from the fact that man has to fend for himself.

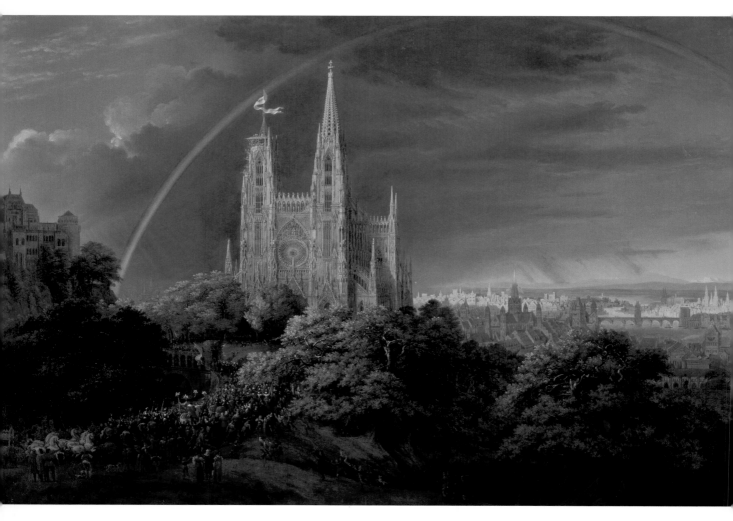

KARL FRIEDRICH SCHINKEL

Medieval Town on a River
1815

Schinkel was not only the most
important Neoclassical architect
in Berlin, he was also a talented
painter. He created a number
of paintings, especially before
he began his career as an architect.
In this painting he envisioned
himself back in the Middle Ages.
The scene depicts an enormous
procession moving toward a Gothic
cathedral that is set beneath
a dramatic sky with a rainbow. For
Schinkel, the medieval building
was much less a religious symbol
than a national one.

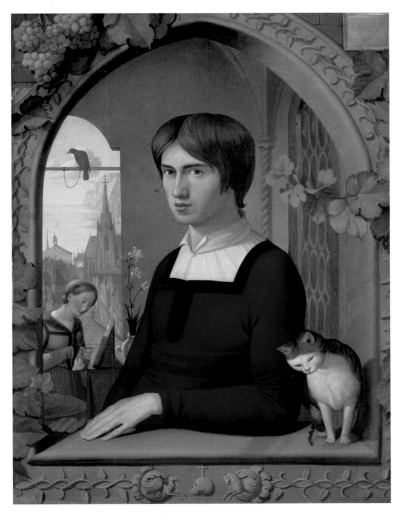

FRIEDRICH OVERBECK

Portrait of the Painter Franz Pforr
1810/65

Friedrich Overbeck and Franz
Pforr, who died young, were the
leading painters of the «Nazarenes,»
a German art movement in Rome.
They were passionate about religious
painting of the Middle Ages and
the Renaissance. This is apparent by
the style of this portrait, which
shows Pforr leading his dream life.
His wife sits in the main room,
modestly busying herself with em-
broideries, while the view of a
small medieval town can be seen
through the window.

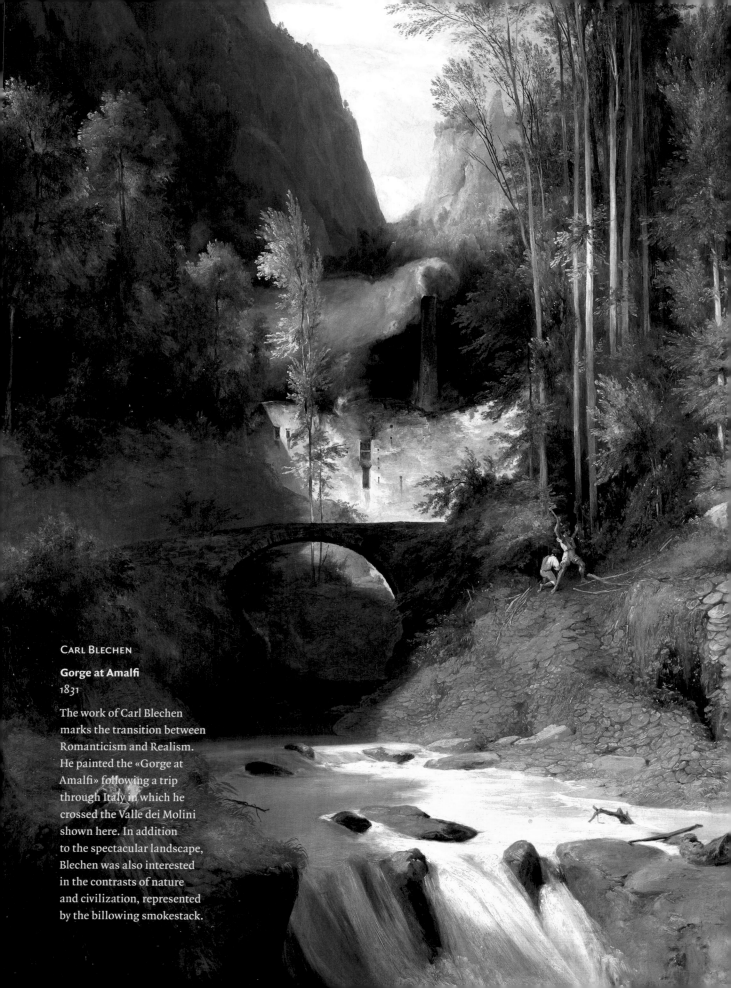

CARL BLECHEN

Gorge at Amalfi
1831

The work of Carl Blechen
marks the transition between
Romanticism and Realism.
He painted the «Gorge at
Amalfi» following a trip
through Italy in which he
crossed the Valle dei Molini
shown here. In addition
to the spectacular landscape,
Blechen was also interested
in the contrasts of nature
and civilization, represented
by the billowing smokestack.

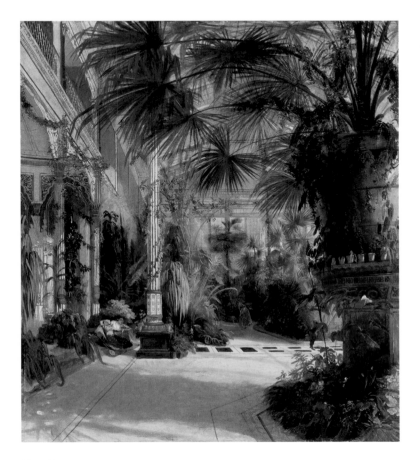

CARL BLECHEN

**The Interior of the Palm House
on Peacock Island**

1832–33

The Palm House, completed
in 1831, was destroyed by
a fire in 1880. When Blechen
painted it, it was one of
the newest attractions in
Berlin. He skillfully captured
the warm humidity of the
sun-dapped room. On the
left he imaginatively added two
female figures dressed in
Middle Eastern clothes, as if
this were actually a palm
garden set in warmer realms.

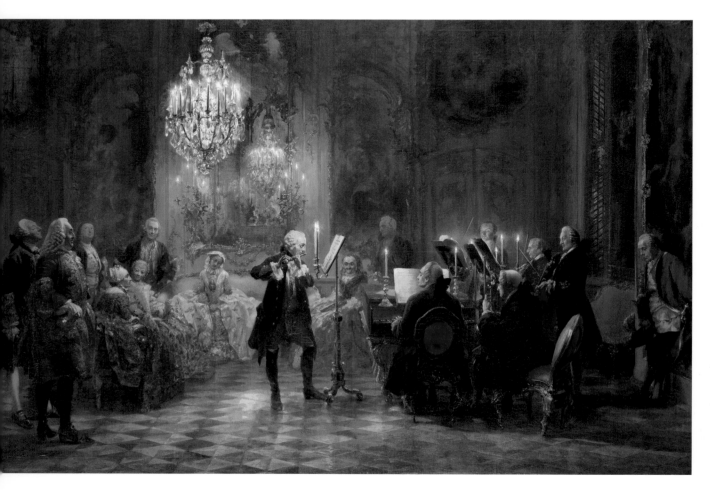

ADOLPH MENZEL

**A Flute Concert of Frederick the Great
at Sanssouci**

1850–52

The work of the painter Adolph Menzel
is represented at the Nationalgalerie
in incomparable scope. Menzel used this
extremely popular work to commemo-
rate an event dating back exactly
100 years before the time it was painted.
It shows an equally sophisticated
and belligerent Frederick the Great
playing the flute during a musical soirée
at his palace Sanssouci in Potsdam,
while his sister Wilhelmine, just visiting
from Bayreuth, sits on a sofa in the
background to the left, listening with
rapt attention.

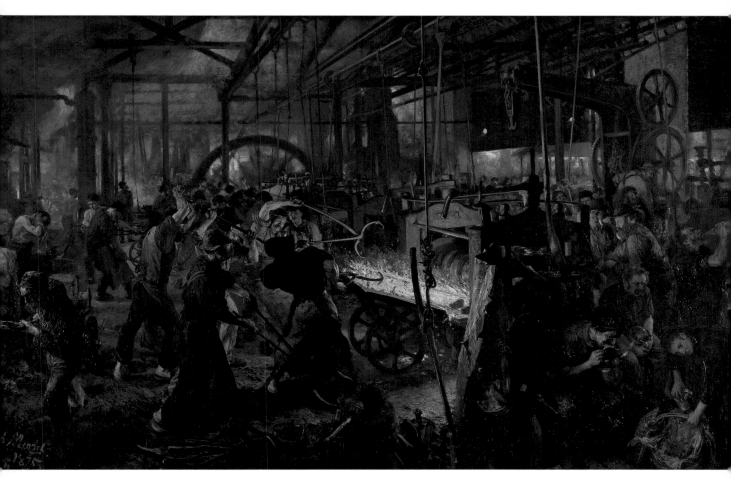

ADOLPH MENZEL

Iron Rolling Mill

1872–75

Menzel addressed himself to
the harsh reality of the present
in the «Iron Rolling Mill.» He
illustrated the hard work in the
steel industry in a ruthlessly
realistic manner that was very
new for the times. Menzel master-
fully captures the gloomy at-
mosphere of the large hall and
the drudgery of the men illumi-
nated by the glowing steel.
To the left men wash after the
work is done, while a meal is
devoured quickly during a break
on the right.

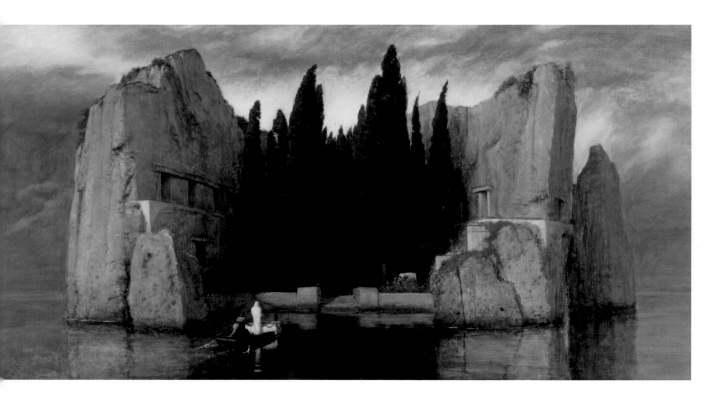

Arnold Böcklin

The Isle of the Dead
1883

The woman who commissioned the
work ordered «a painting for
dreaming» from Böcklin – the most
well-known representative of the
«German Romans.» Böcklin nearly
perfectly satisfied this wish with
his melancholy painting. He depict-
ed an imaginary island as a quiet
place of mourning. A dead man
on a small boat is ferried across the
water. The painting was so success-
ful in the Wilhelminian period
obsessed with death that Böcklin
made five versions of it – the third
hangs in the Nationalgalerie.

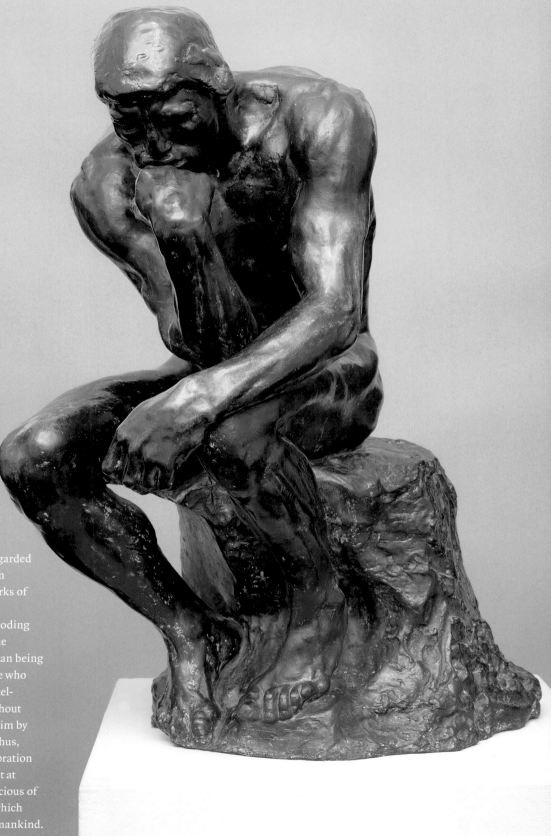

The Thinker
1880—82

Rodin's «Thinker» is regarded
as one of the best known
and most important works of
modern sculpture. The
muscular figure sits brooding
on a rough boulder. «The
Thinker» takes the human being
as its central theme, one who
profits from his own intel-
lectual world alone, without
the security offered to him by
religion, for example. Thus,
the monument is a celebration
of spiritual freedom, but at
the same time it is conscious of
the deep solitude into which
this freedom may lead mankind.

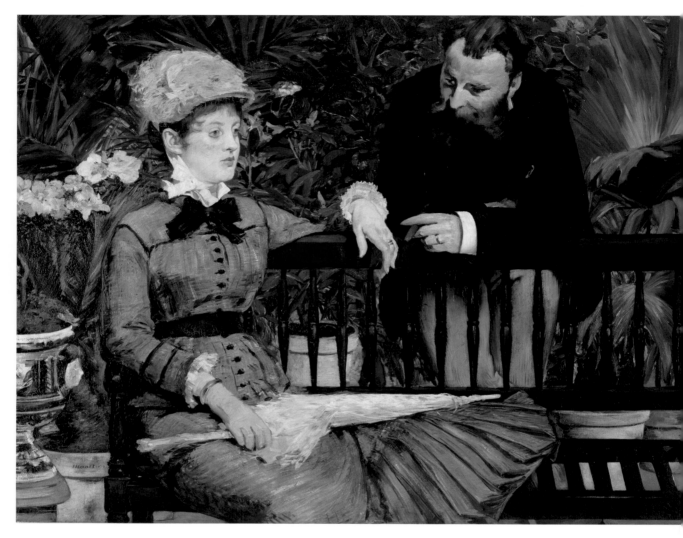

EDOUARD MANET

In the Conservatory

1879

Manet's painting represents
more than just a portrait of
a married couple who were his
friends. Psychologically per-
ceptive and cleverly composed,
it depicts a momentary pause
in conversation. Both figures
appear deeply absorbed in their
own thoughts. The woman
stares into space, while the man
leans over the backrest of the
bench. The lush greenery of the
conservatory is an evocative
contrast to the fine, upper middle
class clothing of both figures.

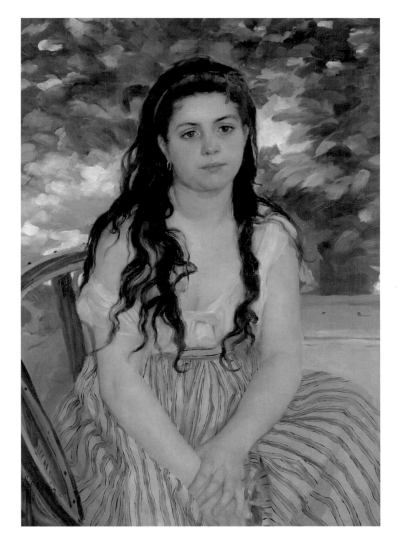

AUGUSTE RENOIR

In the Summer
1868

The dreamy young beauty was
Renoir's lover Lise Tréhot.
While the figure is painted in the
style of 19th century salon painting,
the representation of greenery
in the background hints at Impres-
sionism. Although the National-
galerie had initially collected only
German Art, this restriction was
abolished around 1900 by the former
director Hugo von Tschudi, allow-
ing works by the leading French
painters of the time to come into
the museum.

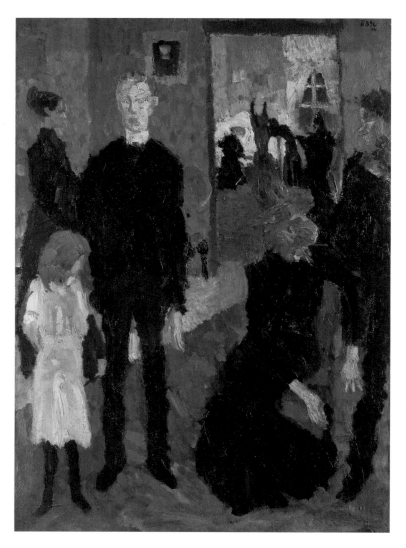

Max Beckmann

Small Death Scene
1906

In this early work, Max Beckmann confronted the inconceivability of death with psychological sensitivity. The family is numb and still, as a relative has just died. Only one figure in the deceased's room, seen in a mirror or through a door, gives theatrical expression to her grief by throwing her arms high into the air, reflecting her uncontrollable pain. The others are frozen in place and appear helpless and alone.

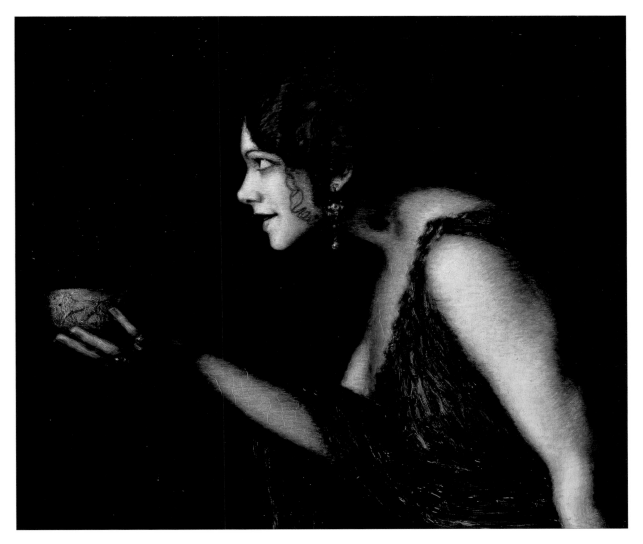

FRANZ VON STUCK

The Actress Tilla Durieux as Circe

c. 1913

Tilla Durieux was one of the most
famous German-speaking actresses
during the period before World
War I. The painter shows her in the
role of Circe, at the moment when
she hopes to induce Odysseus to
accept a putative «cup of pure nectar»
in order to change him into an
animal. Stuck portrayed Durieux/
Circe as a typical femme fatale –
seductive and dangerous all at once.
According to a widespread notion
at the time, the ability to use
deception was viewed as a typically
feminine quality.

Photograph Credits